CATHERINE,
GO WIN
ANOTHER
ONE
FOR
THE GIPPER!

PENLEY

Ronald Reagan and the American Ideal

PENLEY

FOR PARKER P.

Published by
Looking Glass Books
Decatur, Georgia 30030

Copyright © 2010 Steve Penley

Edited by Matt Carrothers

Manufactured in Canada

ISBN 978-1-929619-41-2

Design by Tim McClain
www.mccphotos.com

Book and jacket design by Tim McClain

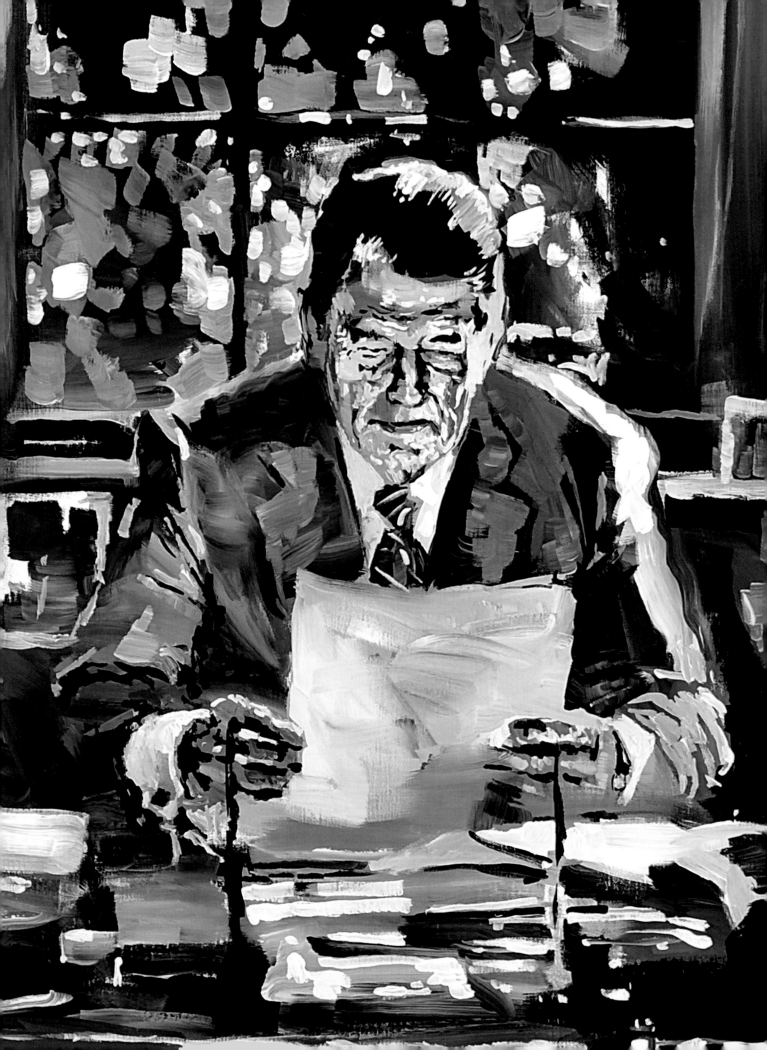

RONALD REAGAN AND THE AMERICAN IDEAL

PENLEY

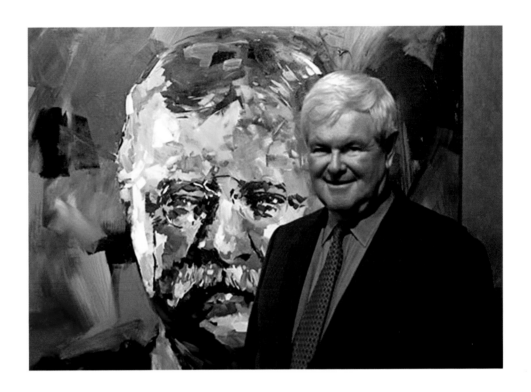

Foreword by Newt Gingrich

In the spring of 1975, as a young professor of history at the University of West Georgia, I was stirred by the message in a speech Ronald Reagan delivered at the second annual Conservative Political Action Committee, the now mammoth and influential convention colloquially known as CPAC.

Reagan stated, "Our people look for a cause to believe in. Is it a third party we need, or is it a new and revitalized second party, raising a banner of no pastels, but bold colors, which make it unmistakably clear where we stand on all of the issues troubling the people?"

His remarks seemed to transcend the conservative activists in attendance, and spoke to the frustrations of an entire nation disheartened from the Vietnam War, Watergate, a fledgling economy and rapidly expanding government growth, propagated by presidents from both major political parties.

Ronald Reagan called on the majority of inherently conservative Americans across the country to reroute our nation toward its founding principles; the principles so elegantly and timelessly outlined in the Declaration of Independence and protected by the U.S. Constitution.

Though our libraries and bookstores teem with biographies detailing the minutest details of their subjects' lives, we often focus on the short years spent at the apex of their careers. It's easy to forget, for example, that Ronald Reagan's career did not begin with a speech in 1975, his narrow defeat by Gerald Ford for the 1976 Republican presidential nomination, and his return in 1980 to secure the presidency in a landslide victory. Conversely, his was a career marked with a consistent message and distinct method of delivery more than forty years in the making, beginning in 1933 as a radio sports announcer, an actor, the national spokesman for General Electric, and two terms as Governor of California.

Ronald Reagan's life and achievements were our quintessential interpretation of the American dream. As important, however, are the values and ideals he constantly expressed and fought to reinstill in the country he so cherished. Reagan was a patriot who never apologized for American exceptionalism, and an optimist who challenged his fellow citizens, and himself, to set and exceed exceptional goals. He was the rare political figure who was equally as comfortable at a state dinner as in a Midwest manufacturing plant, and he instinctively knew that common sense solutions could unwind the byzantine stranglehold his predecessors and opponents in Congress wrapped around our nation's innovative spirit.

Reagan's character was also uniquely American. He literally rode in from the West, high in the saddle atop his white horse, with a clear mission to clean up Washington and root out evil throughout the world.

In these beautiful pages you will find a book not just about Ronald Reagan, but bold colors and our fundamental American ideals. Steve Penley's bold and vibrant portraits depict Ronald Reagan at every stage of his storybook life, our nation's founding fathers, and many of the distinctly American icons we most revere. You will also see and read about Reagan's call to return America to our founding principles, which form our foundation and have sustained our American family through the best and worst chapters of our history.

Steve's book is also a call to action, to both our elected leaders and all American citizens concerned for the future of our country. It is a call to not merely repeat the words of the Great Communicator, but to make them manifest in our own lives. A nation united behind the goal of keeping lit the flames of liberty will achieve Ronald Reagan's vision of America as a Shining City, visible in even the darkest corners of Earth, where anyone can achieve their dreams.

In 1856, Alexis de Tocqueville wrote, "History is a gallery of pictures in which there are few originals and many copies."

There will never be another Ronald Reagan, but his life will serve in perpetuity as an inspiration to all of us who cherish and fight for freedom and liberty in this beautiful land we call America. I hope this book inspires you to protect our shared American ideals, and that you will proudly display it in your home.

Newt Gingrich
September, 2010

RONALD REAGAN AND THE AMERICAN IDEAL

PENLEY

THE 80s

DURING THE 1980s, IT SEEMED AS THOUGH AMERICA WAS RIDING ON SOME SORT OF HIGH. WHEN MY GROUP OF FRIENDS AND I WERE IN COLLEGE, THERE WAS AN ENERGY IN THE AIR WHICH MADE US FEEL AS IF ANYTHING WAS POSSIBLE. AMERICANS FELT GOOD ABOUT WHO THEY WERE AND WHAT THEIR ROLE WAS IN THE WORLD. I BELIEVE REAGAN WAS RESPONSIBLE FOR THIS FEELING OF OPTIMISM.

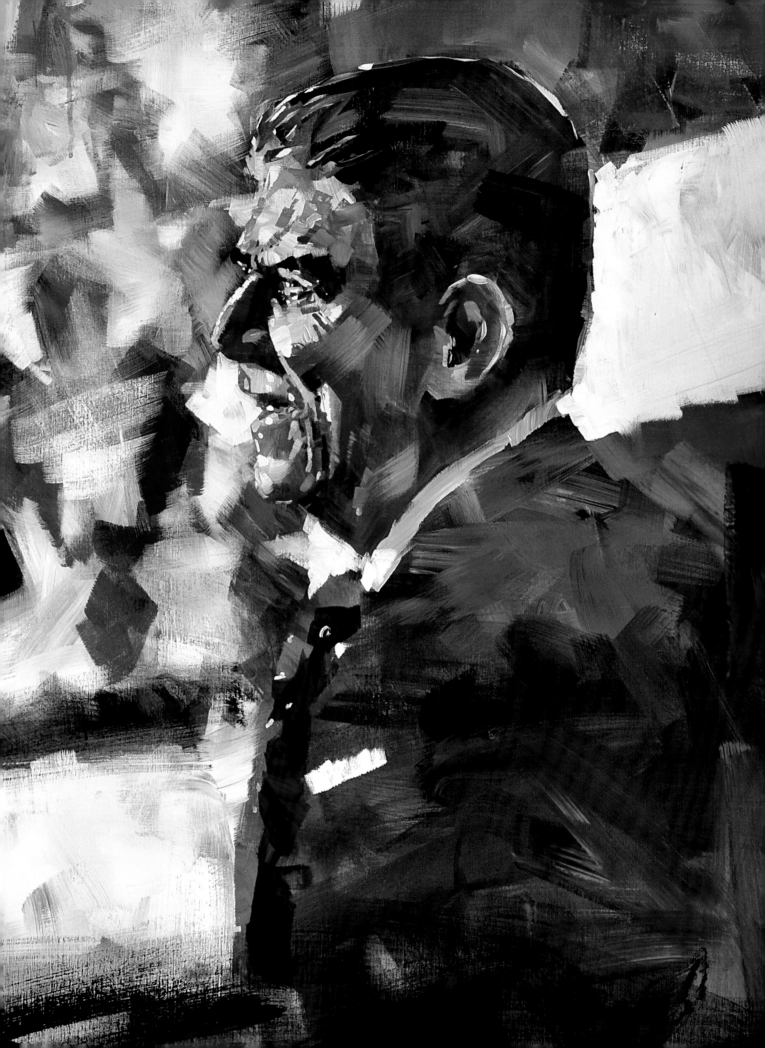

THE 80s

I GUESS YOU COULD SAY HIS OPTIMISM TRICKLED DOWN FROM THE TOP, SINCE MY FRIENDS AND I EXPERIENCED OUR COMING OF AGE DURING THIS TIME, REAGAN HAS AN EVEN MORE POIGNANT PLACE IN OUR COLLECTIVE EXPERIENCE. HOW COULD WE GO FROM SUCH A HIGH TO SUCH A LOW IN THAT SHORT AMOUNT OF TIME? A LEADER SHOULD BE AN EXAMPLE OF WHAT IS BEST IN A NATION. A LEADER SHOULD EXPRESS THE HIGHEST IDEALS OF A NATION. REAGAN WAS THE AMERICAN IDEAL.

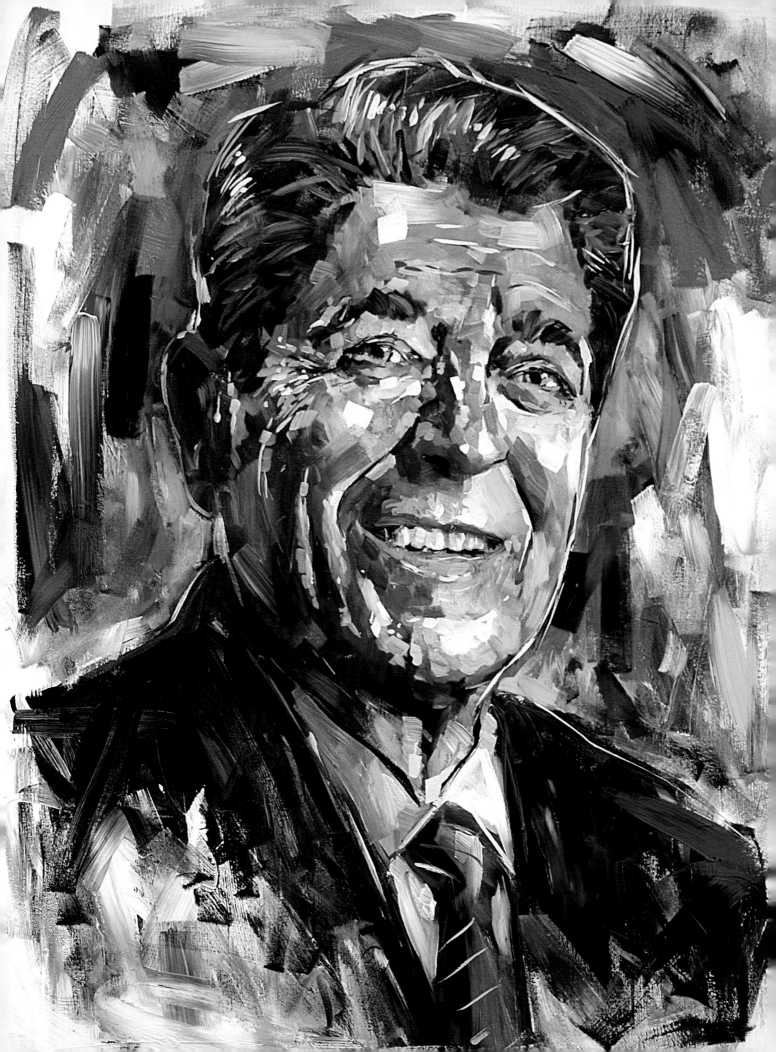

WASHINGTON SAID THE CITY OF MAN COULD NOT SURVIVE WITHOUT RECOGNIZING THE CITY OF GOD. "THE VISIBLE CITY WILL PERISH WITHOUT THE INVISIBLE CITY."

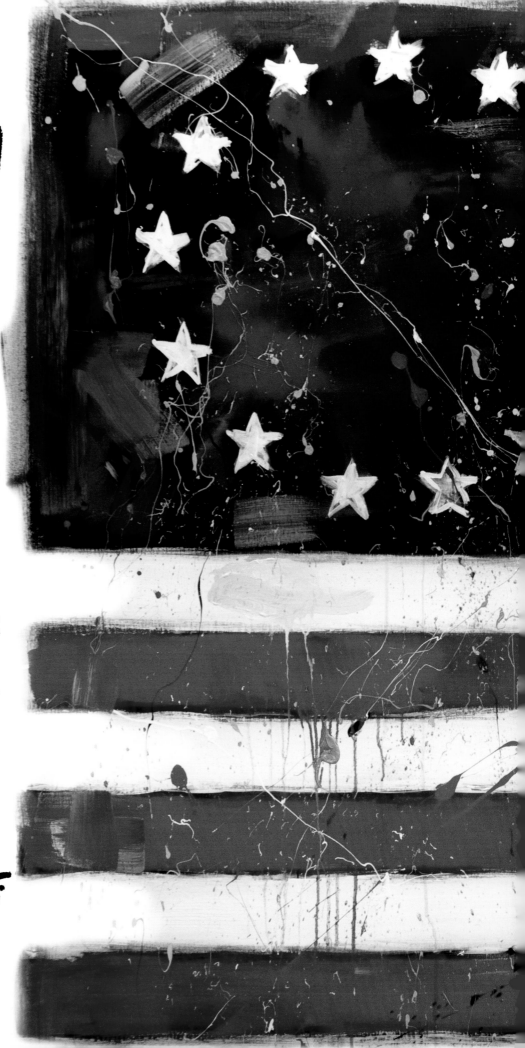

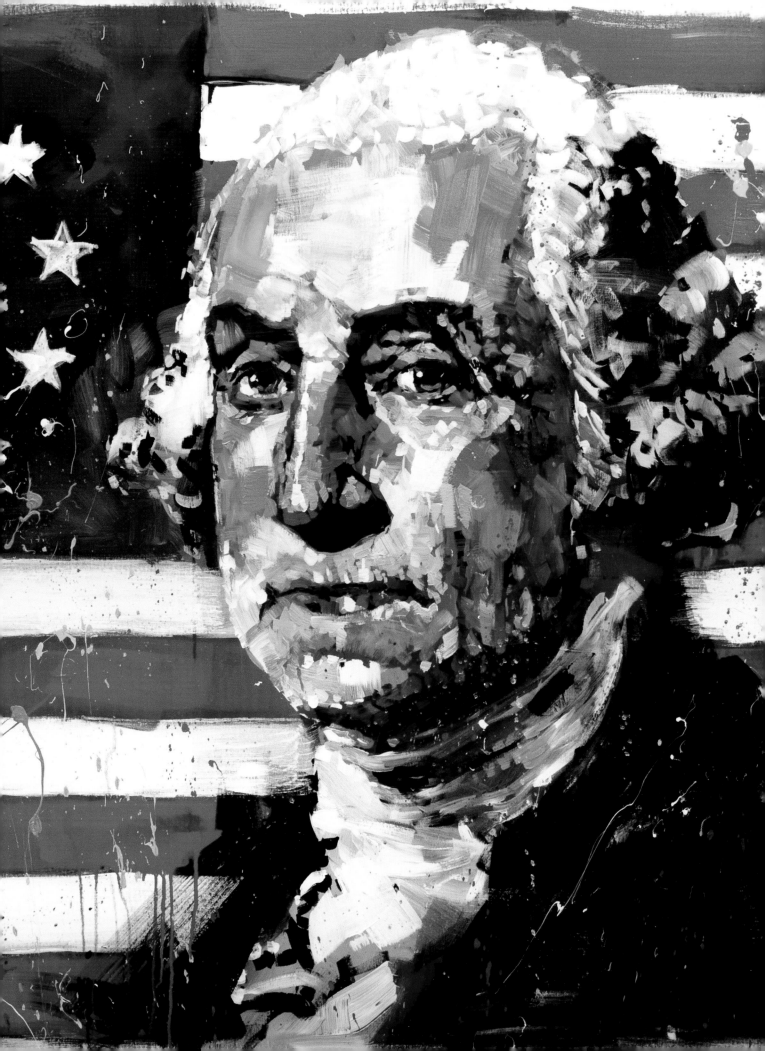

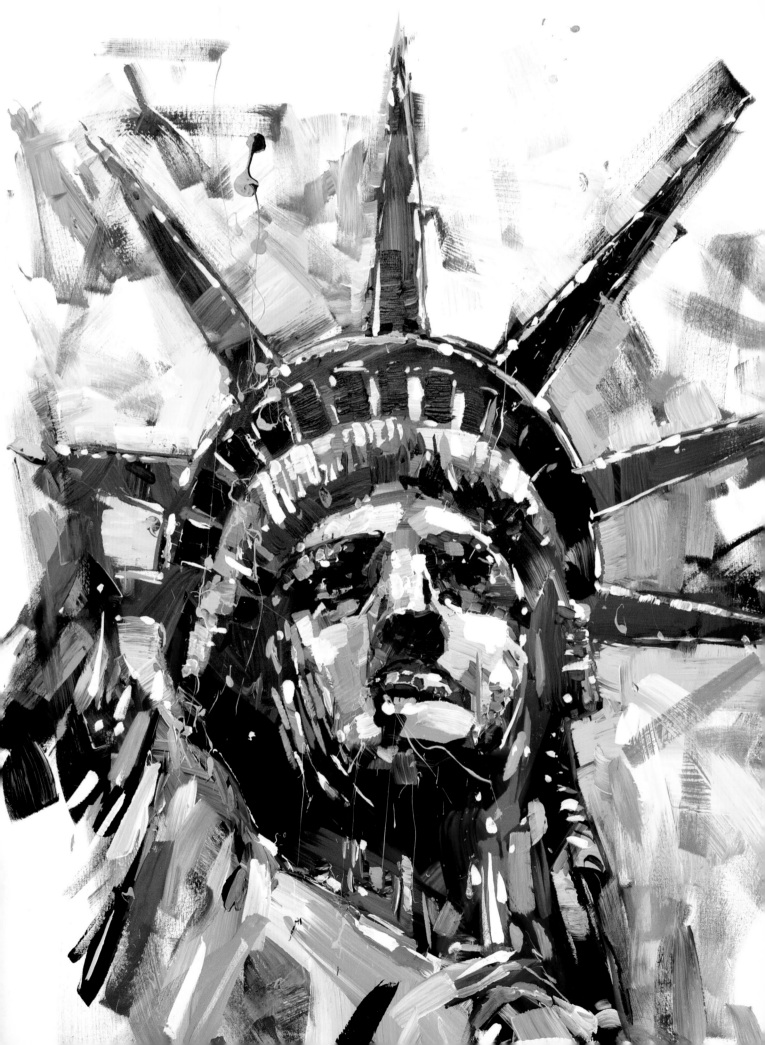

AS CHILDREN, WE ALWAYS BELIEVED THAT AMERICA WAS THE GOOD GUY. IT NEVER OCCURRED TO US TO THINK ANYTHING ELSE. IN WARS, AMERICANS WERE THE LIBERATORS, AND IN WESTERNS, THE SHERIFF GUNNED DOWN THE VILLAIN AT THE END OF THE SHOW. TIMES HAVE CHANGED SINCE THEN.

TODAY'S WAR MOVIES OFTEN PORTRAY AMERICANS AS EVIL AGGRESSORS, AND IN WESTERNS, WELL, IN THE FEW THAT ARE MADE, YOU CANNOT TELL WHO IS GOOD AND WHO IS BAD. IN TODAY'S POLICE DRAMAS, THE COPS ARE OFTEN CORRUPT AND THE CROOKS ARE OFTEN GLORIFIED.

POPULAR CULTURE AND ENTERTAINMENT IN TODAY'S AMERICA DRAWS, AT BEST, AMBIGUOUS DISTINCTIONS' BETWEEN GOOD AND EVIL. WHERE ARE THE ROY ROGERS AND THE JOHN WAYNES OF TODAY? DO WE NO LONGER ROOT FOR THE GOOD GUY OVER THE BAD GUY? MAYBE TODAY'S LEADERS AND ROLE MODELS HAVE BLURRED THE DISTINCTIONS BETWEEN GOOD AND EVIL, AND THAT KIND OF HERO NO LONGER RINGS TRUE.

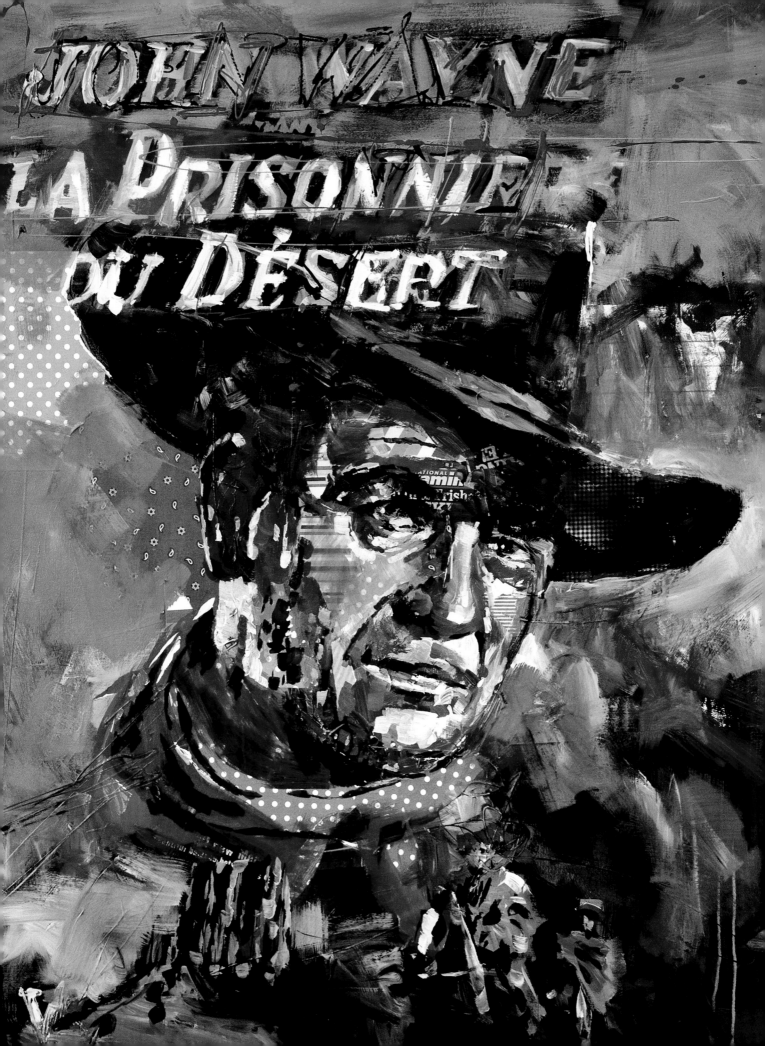

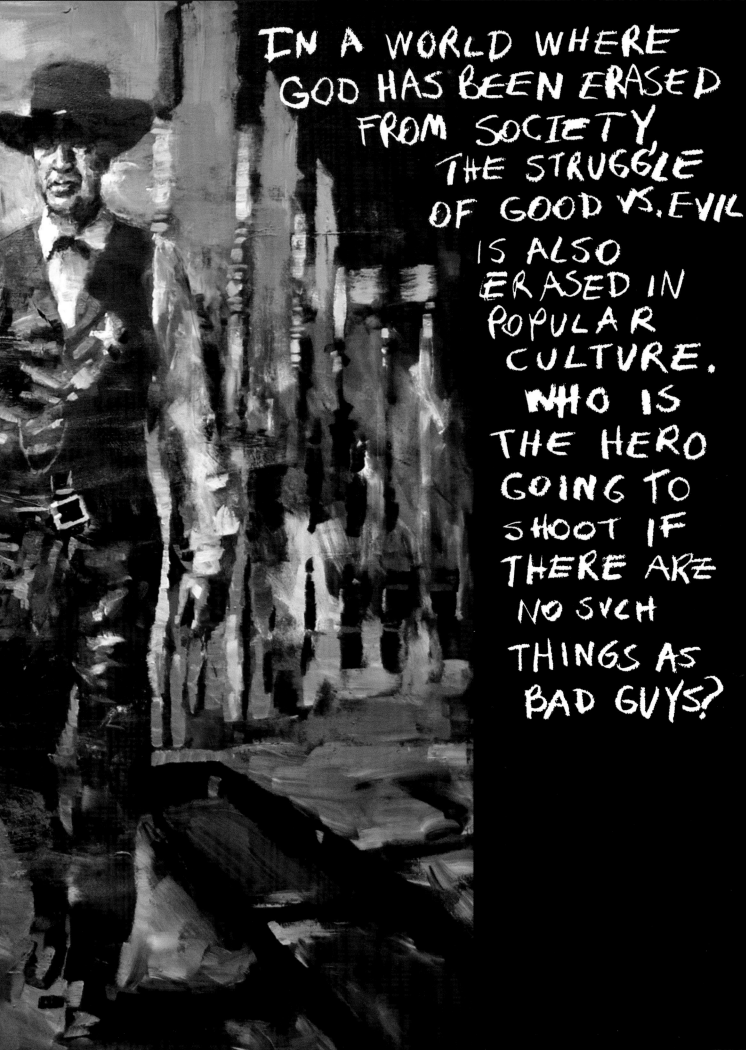

IN A WORLD WHERE GOD HAS BEEN ERASED FROM SOCIETY, THE STRUGGLE OF GOOD VS. EVIL IS ALSO ERASED IN POPULAR CULTURE. WHO IS THE HERO GOING TO SHOOT IF THERE ARE NO SUCH THINGS AS BAD GUYS?

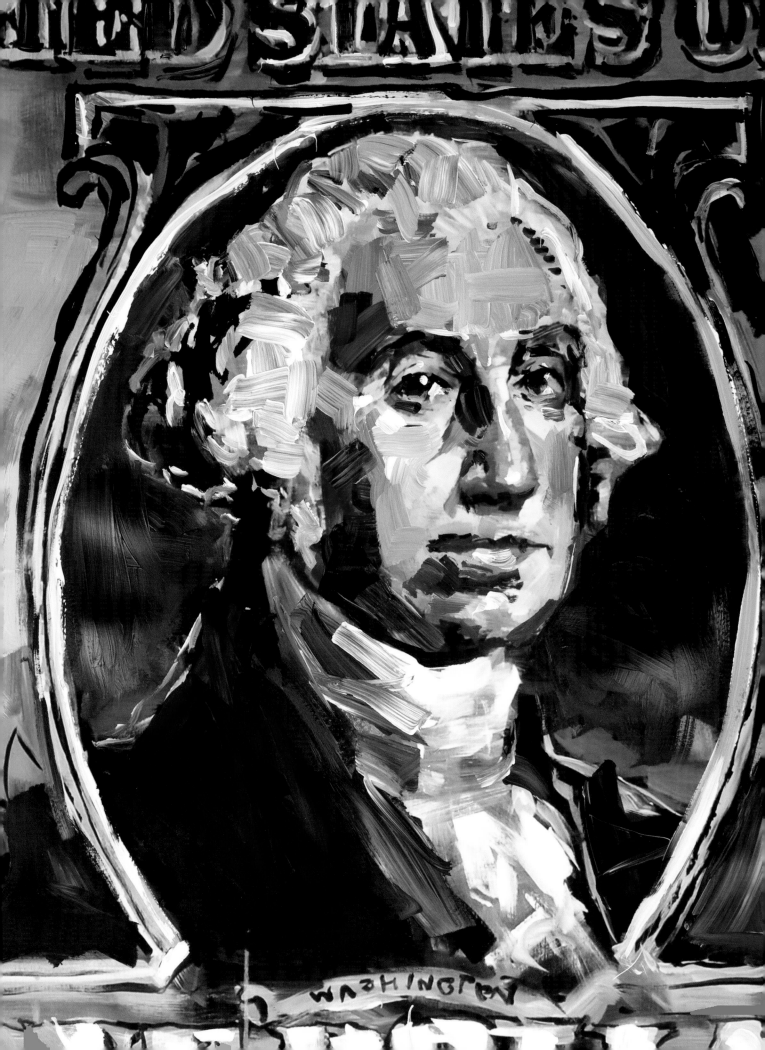

WE LIVE IN THE GREATEST COUNTRY IN THE HISTORY OF CIVILIZATION, WHAT MADE US SO SUCCESSFUL? WHAT HAS SUSTAINED US, AND WHAT HAS CAUSED US TO BECOME SO WEALTHY AND POWERFUL IN SUCH A SHORT SPAN OF TIME? THE ANSWER LIES IN THE FOUNDATIONS OF AMERICA. OUR FOUNDATIONS WERE ABSOLUTE. OUR FOUNDATIONS ARE WHAT BROUGHT OUR ANCESTORS TO OUR SHORES, SO WHY SHOULD WE ABANDON THEM?

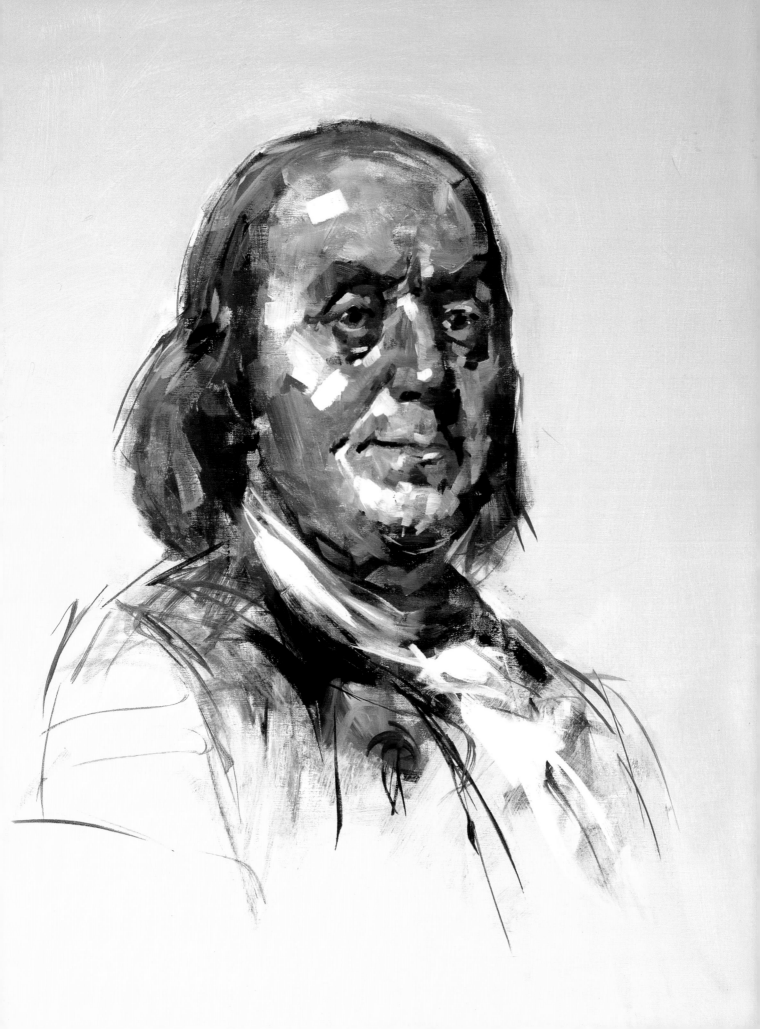

EVERY GENERATION SEEMS TO SHOCK THE ONE BEFORE IT, AND THE ONE BEFORE IT IS EQUALLY CONVINCED THAT THOSE WHO ARE YOUNGER WILL SURELY DRIVE THE NATION TO RUIN. BUT TODAY'S KIDS DO NOT EVEN SEEM TO SPEAK THE SAME LANGUAGE. SOME ARGUE THAT TECHNOLOGY IS THE PROBLEM. THEY SAY CHILDREN SPEND TOO MUCH TIME ON COMPUTERS AND VIDEO GAMES AND THAT KEEPS THEM FROM BEING ABLE TO RELATE TO REAL LIFE. ARE THEIR ATTENTION SPANS SO SHORT THAT THEY ARE INCAPABLE OF HOLDING CONVERSATIONS LIKE THE GENERATIONS THAT PRECEDED THEM? I THINK THE PROBLEM IS DEEPER THAN THAT.

TODAY'S CHILDREN HAVE GROWN
UP IN A WORLD IN WHICH NOTHING
HAS BEEN CONSIDERED ABSOLUTE.
MANY OF THEM CLEARLY REMEMBER
THEIR PRESIDENT ON TRIAL FOR
LYING UNDER OATH, AND THEN
STRUGGLING WITH THE DEFINITION
OF THE WORD "IS." HOW DO
WE EXPECT THEM TO UNDERSTAND
THE DIFFERENCE BETWEEN RIGHT
AND WRONG IN A WORLD WHERE
RIGHT AND WRONG ARE ONLY
WHAT WE SAY IT IS AT A
GIVEN TIME? HOW WOULD THIS
NEW GENERATION GRASP THE
CONCEPT OF AN "EVIL EMPIRE"
IN A WORLD WHERE THERE
IS NO GOD?

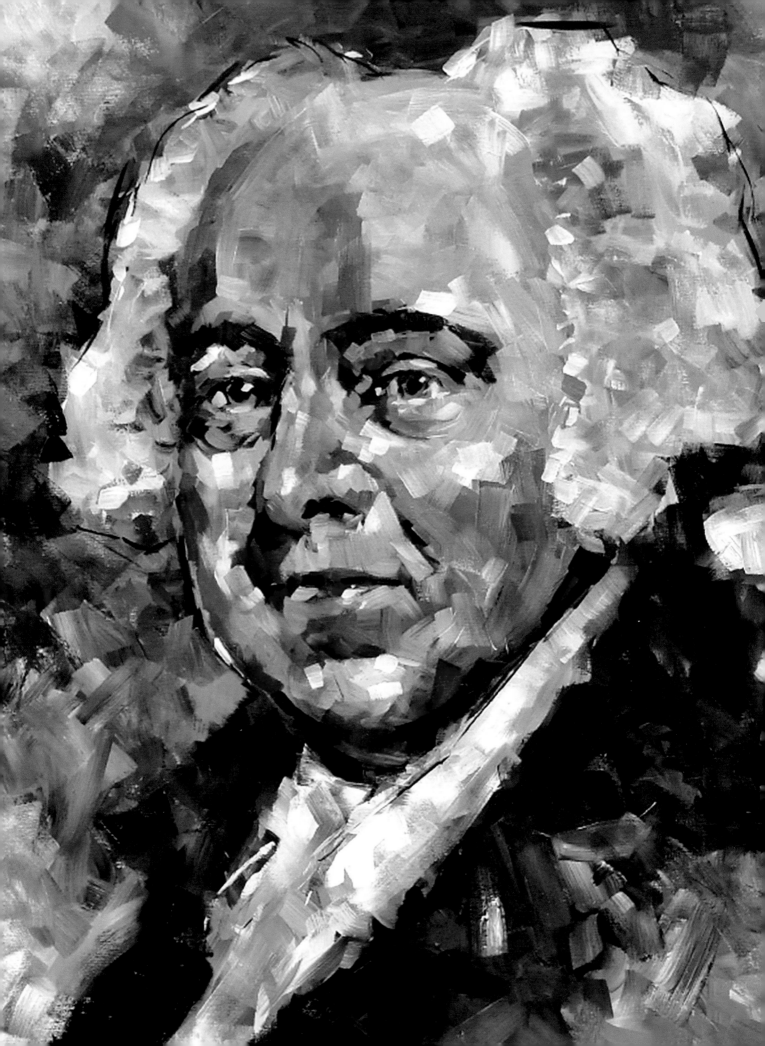

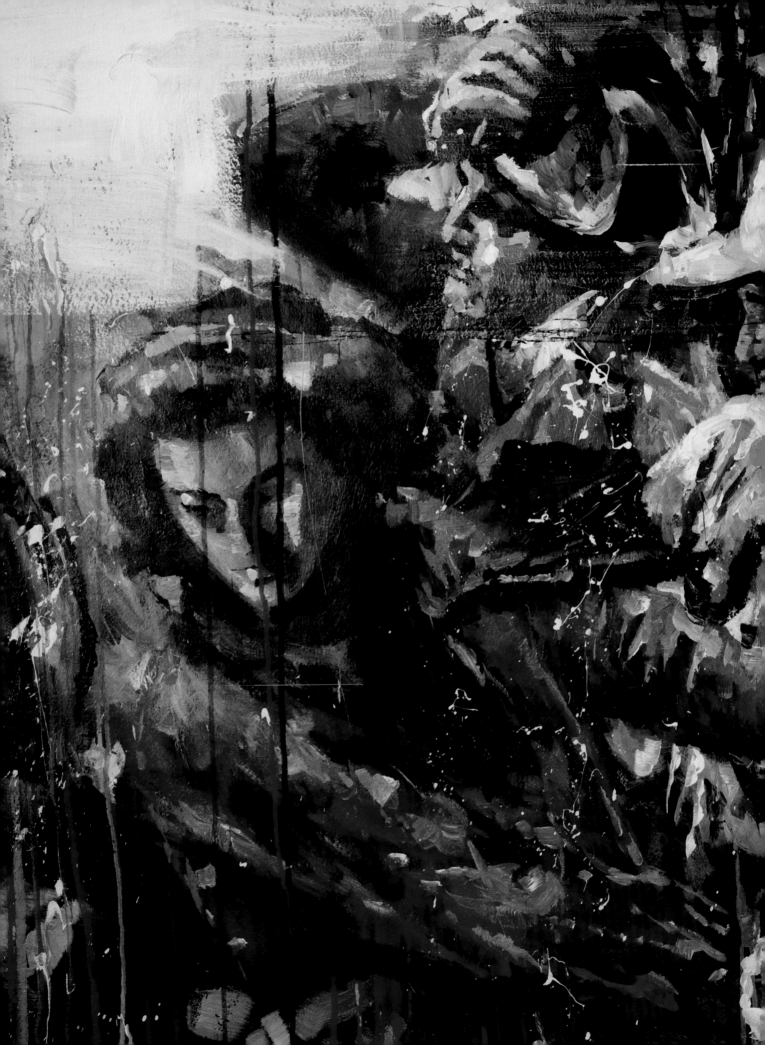

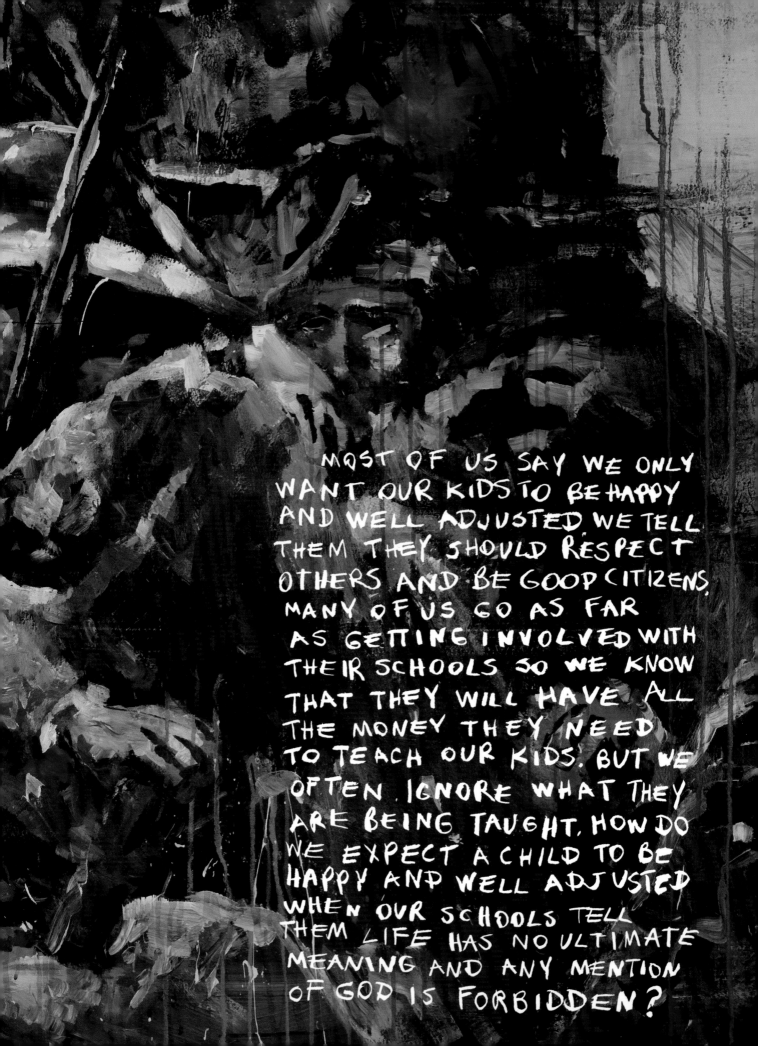

MOST OF US SAY WE ONLY WANT OUR KIDS TO BE HAPPY AND WELL ADJUSTED. WE TELL THEM THEY SHOULD RESPECT OTHERS AND BE GOOD CITIZENS. MANY OF US GO AS FAR AS GETTING INVOLVED WITH THEIR SCHOOLS SO WE KNOW THAT THEY WILL HAVE ALL THE MONEY THEY NEED TO TEACH OUR KIDS. BUT WE OFTEN IGNORE WHAT THEY ARE BEING TAUGHT. HOW DO WE EXPECT A CHILD TO BE HAPPY AND WELL ADJUSTED WHEN OUR SCHOOLS TELL THEM LIFE HAS NO ULTIMATE MEANING AND ANY MENTION OF GOD IS FORBIDDEN?

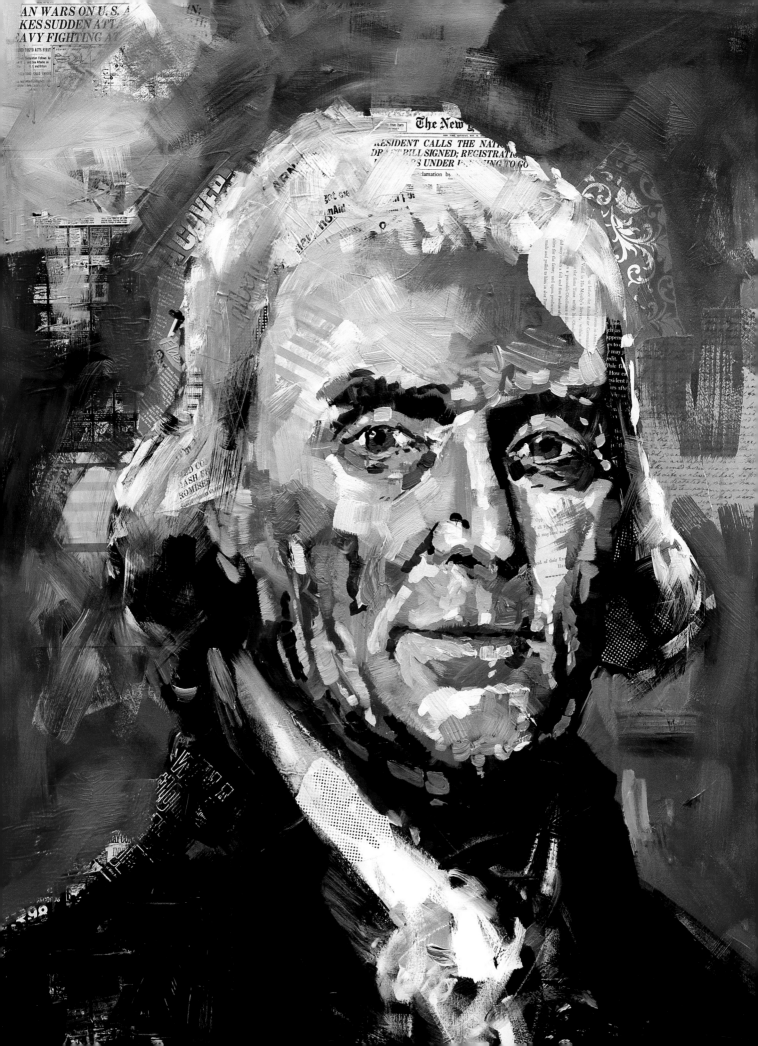

IF YOU TALK TO THE AVERAGE COLLEGE KID TODAY AND ASK HIM OR HER SIMPLE QUESTIONS ABOUT AMERICAN HISTORY, YOU WILL BE VERY SURPRISED BY WHAT THEY DO NOT KNOW. THERE ARE QUESTIONS THAT YOU WOULD NOT ASK FOR FEAR OF INSULTING THEIR INTELLIGENCE, BUT ASK ANYWAY. THE OBVIOUS FACTS OF AMERICAN HISTORY ARE PROBABLY LOST ON MOST OF THEM. NOT ONLY ARE THE UNDERACHIEVING STUDENTS GUILTY OF THIS, BUT EVEN HONOR STUDENTS ARE OFTEN AMAZINGLY IGNORANT OF AMERICA'S PAST.

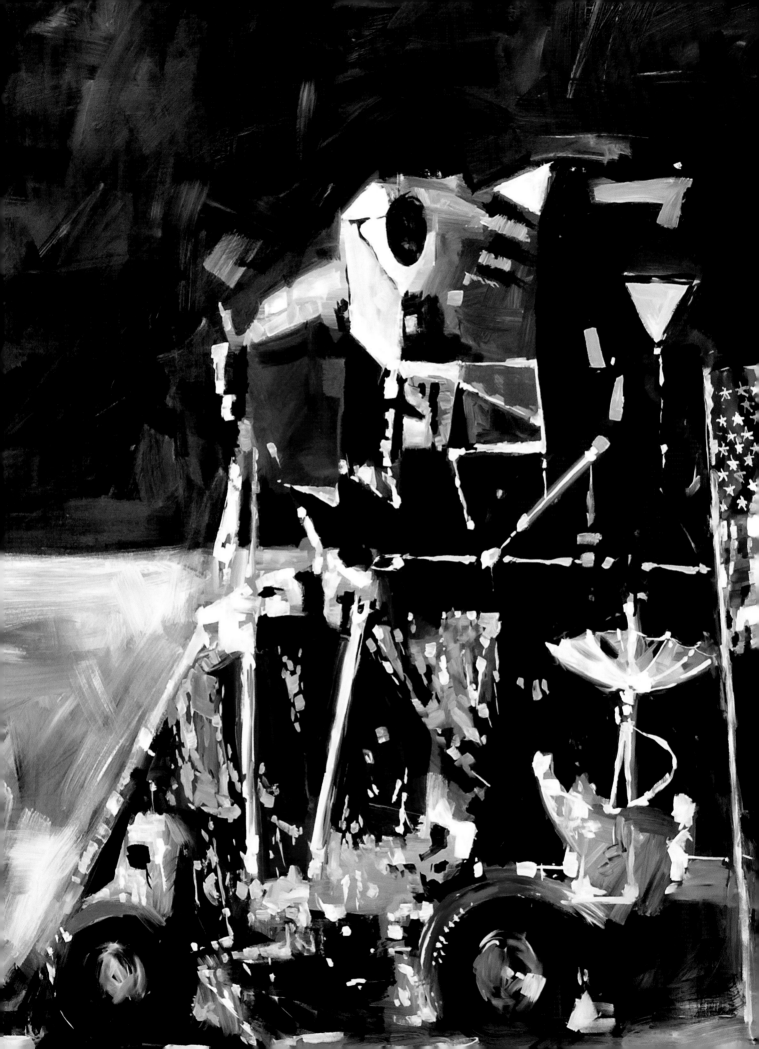

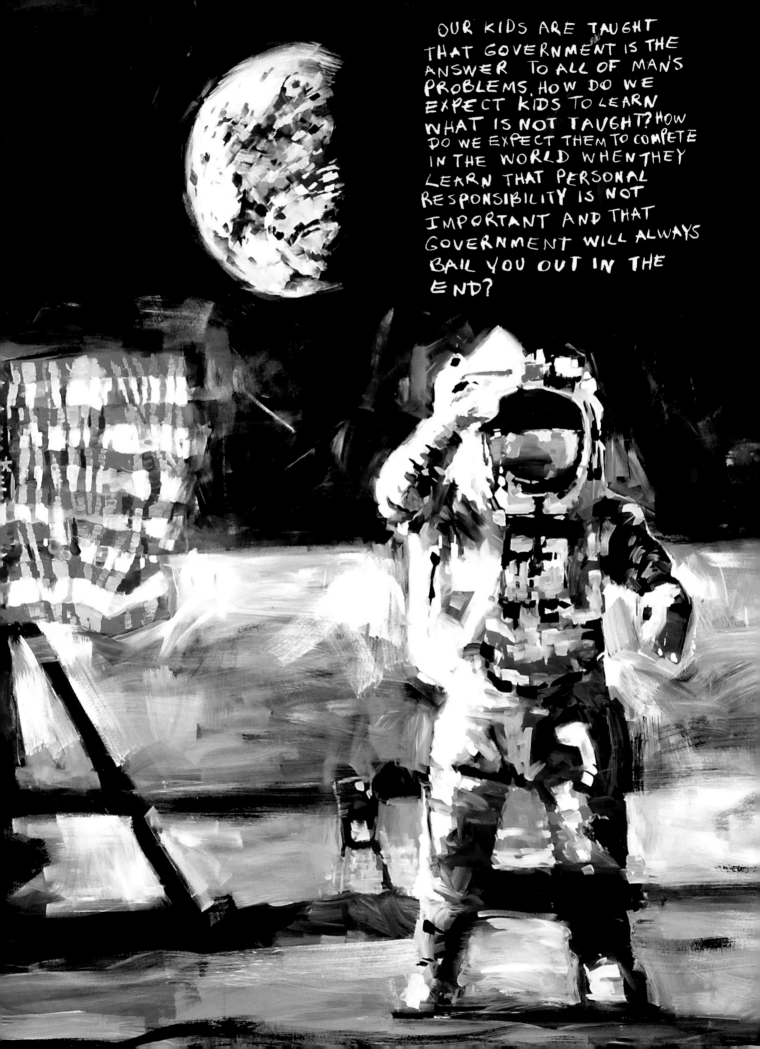

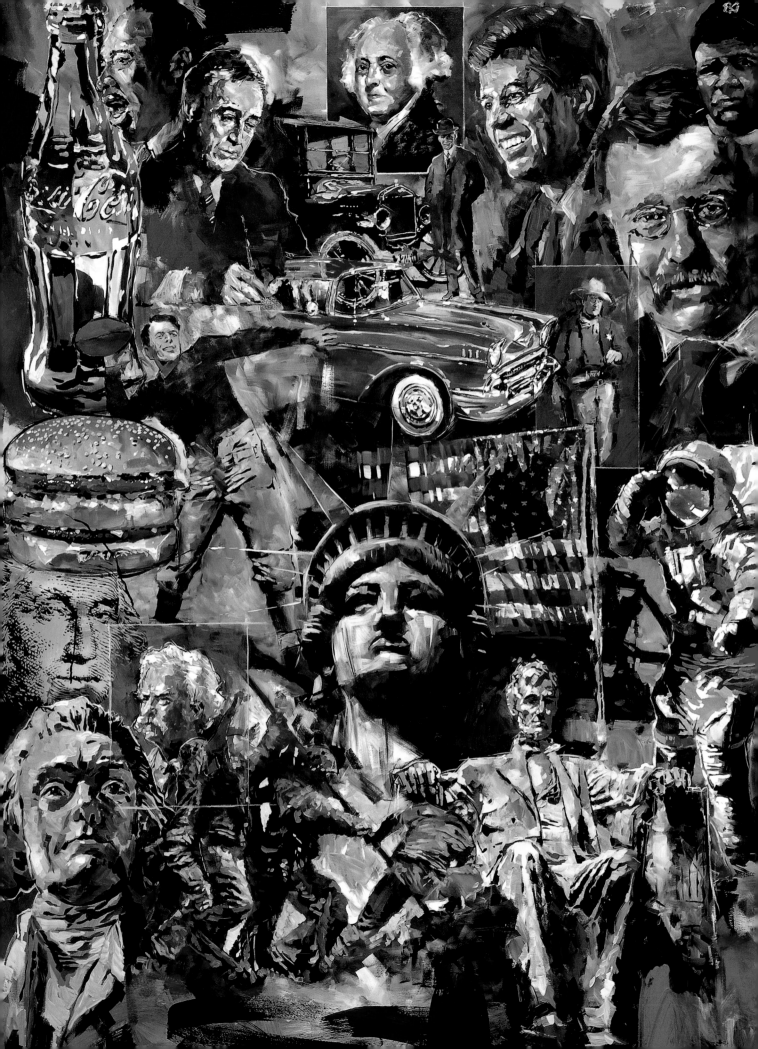

EVERY FOUR YEARS WE
HEAR CANDIDATES OFFER
US MORE GOVERNMENT SOLUTIONS
TO PROBLEMS WHICH WERE
CAUSED BY TOO MUCH GOVERNMENT
IN THE FIRST PLACE. THEY
KNOW THAT THEY CAN GET
AWAY WITH IT BECAUSE
THEY KNOW THAT WE HAVE
FORGOTTEN OUR ROOTS.
THEY KNOW THAT OUR
YOUTH HAVE NOT BEEN
TAUGHT WHAT MADE
AMERICA GREAT.

SOME OF TODAY'S LEADERS ARE BOLD
ENOUGH TO TRAVEL AROUND THE
WORLD TELLING PEOPLE ABOUT THE
EVILS OF AMERICA. THEY LIKE TO
REMIND US AND THE WORLD OF OUR
SHORT COMINGS AND THEY RARELY
REMEMBER THE QUALITIES WHICH
MOST OF US SEE CLEARLY. WE
HAVE POLITICIANS TODAY WHO
SAY AMERICA NEEDS TO BE
FUNDAMENTALLY CHANGED AND
THAT WE SHOULD PUT LESS
EMPHASIS ON OUR NATIONS FOUNDING
IN THE SCHOOLS. TO THESE PEOPLE
THE ONLY VALID ACCOMPLISHMENTS
OF MANKIND ARE DONE WITH
THE HELP OF GOVERNMENT. WHY
DO WE EXPECT OUR CHILDREN
TO LOVE AMERICA WHEN OUR OWN
LEADERS HOLD IT IN CONTEMPT?

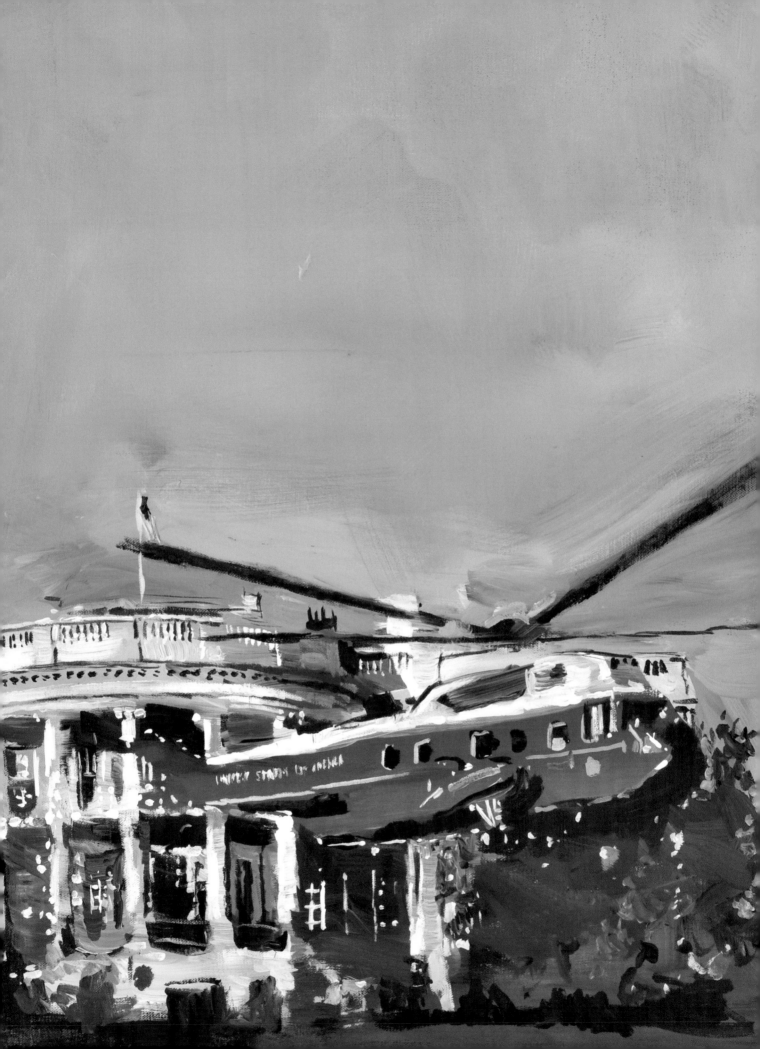

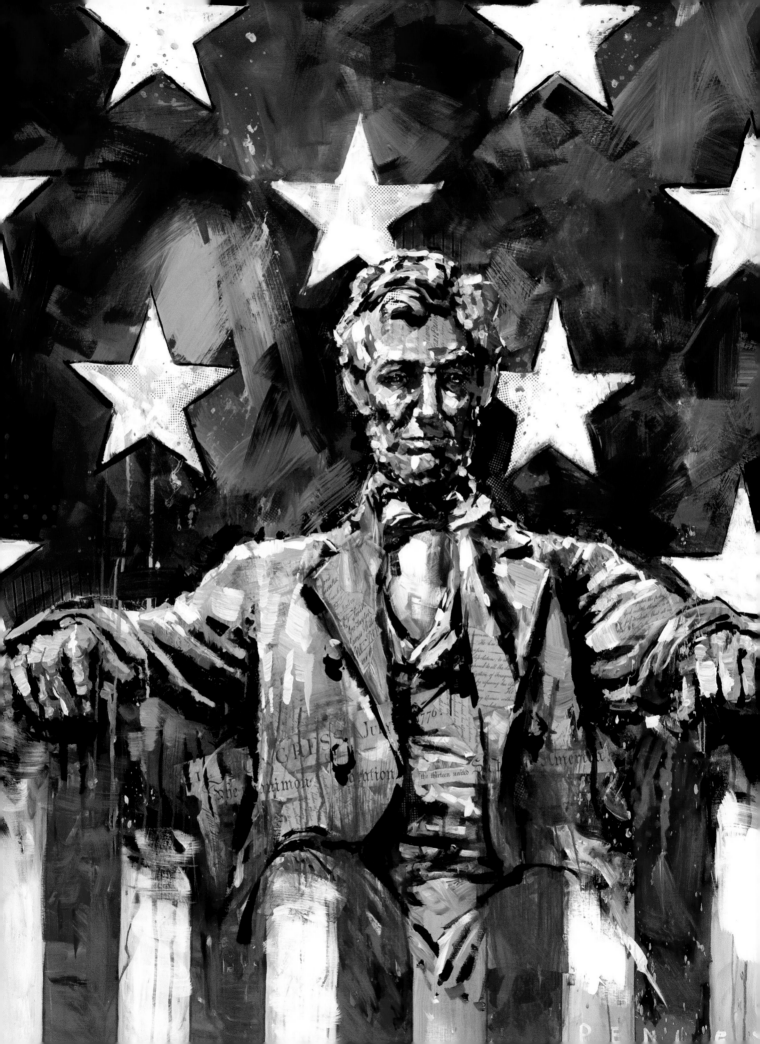

WE HAVE PULLED THE RUG OUT FROM UNDERNEATH OUR CHILDREN. WE HAVE ROBBED THEM OF THEIR HISTORY. WE HAVE FORGOTTEN THE FAITH OF OUR FOUNDERS FROM WHICH ALL OF OUR FREEDOMS ARE DERIVED. AMERICA BROKE AWAY FROM THE OLD WORLD WHERE MEN WERE SUBJECTS OF THE STATE. IN AMERICA, THE STATE IS THE SUBJECT OF THE PEOPLE. OUR FOUNDATION IN GOD WAS NOT JUST A TOOL OF THE MONARCHY WHICH WAS USED TO CONTROL THE MASSES. OUR FOREFATHERS HAD A REAL FAITH WHICH LED TO A TRUE BELIEF IN THE DIGNITY OF THE INDIVIDUAL. ALL OF OUR RIGHTS COME FROM THAT PERCEIVED DIGNITY. OUR LAWS, OUR FREE MARKET ECONOMY, AND OUR EGALITARIAN CULTURE COME FROM THESE FOUNDATIONS.

IN AMERICA, WE HAVE ALWAYS
RECOGNIZED OUR CREATOR AS
THE ULTIMATE SOURCE OF LAW
AND JUSTICE AND THAT HAS
SUSTAINED US AND MADE US
STRONG UNTIL NOW. HISTORY HAS
GIVEN US A CLEAR LESSON
OF WHAT SOCIETY BECOMES
UNDER ATHEISTIC RULE.
IT BREAKS DOWN INTO A
SYSTEM WHERE HUMAN LIFE
HAS NO VALUE OUTSIDE OF
ITS SERVICE TO THE STATE.
OUR FOREFATHERS KNEW
THAT A NATION COULD STAND
THE TEST OF TIME ONLY IF
IT WAS A NATION UNDER GOD.

OUR FOUNDERS HAD A VISION WHICH WAS TEMPERED BY THEIR KNOWLEDGE OF THE NATURE OF MAN AND HIS GOVERNMENTS. THE FRENCH REVOLUTION PRODUCED MANY GREAT SOUNDING IDEAS ABOUT LIBERTY, BUT THE LEADERS OF THAT REVOLUTION DID NOT ACKNOWLEDGE THE GOD THAT WAS THE SOURCE OF THAT FREEDOM. IT DID NOT TAKE LONG FOR THESE MEN TO BECOME JUST AS EVIL AS THE MEN THEY HAD JUST REVOLTED AGAINST. ONCE WE REMOVE GOD FROM PUBLIC LIFE THERE IS NO ULTIMATE SOURCE OF RIGHT AND WRONG AND THUS NO CONSTRAINT ON EVIL OF ANY KIND.

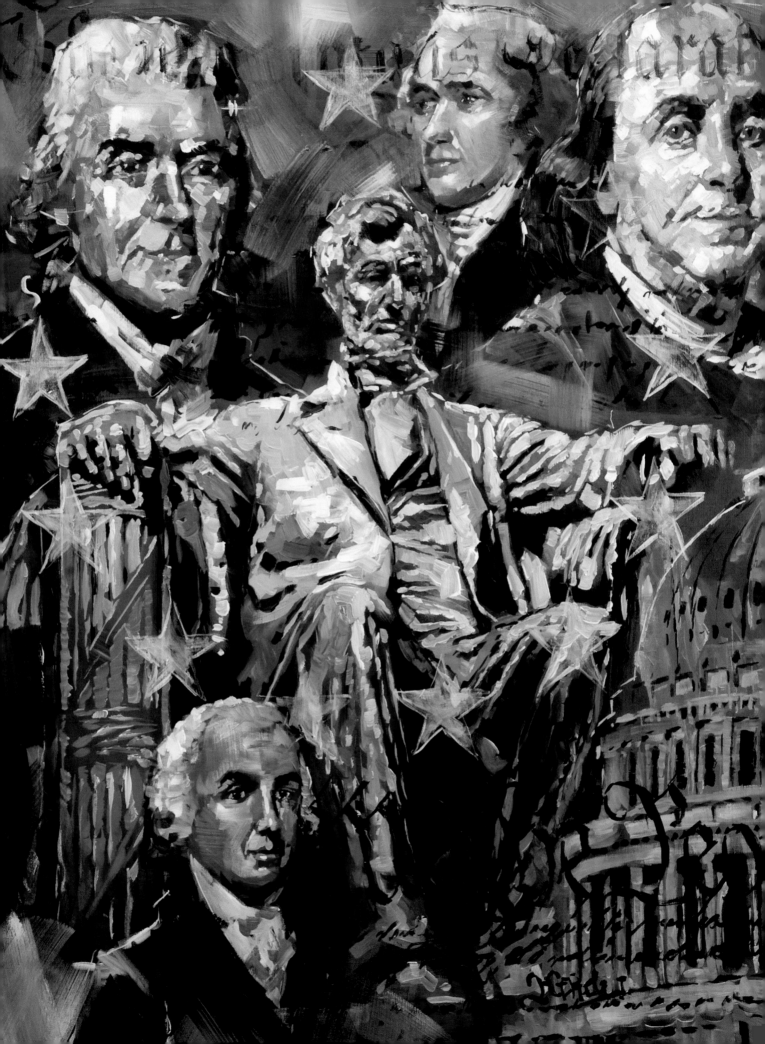

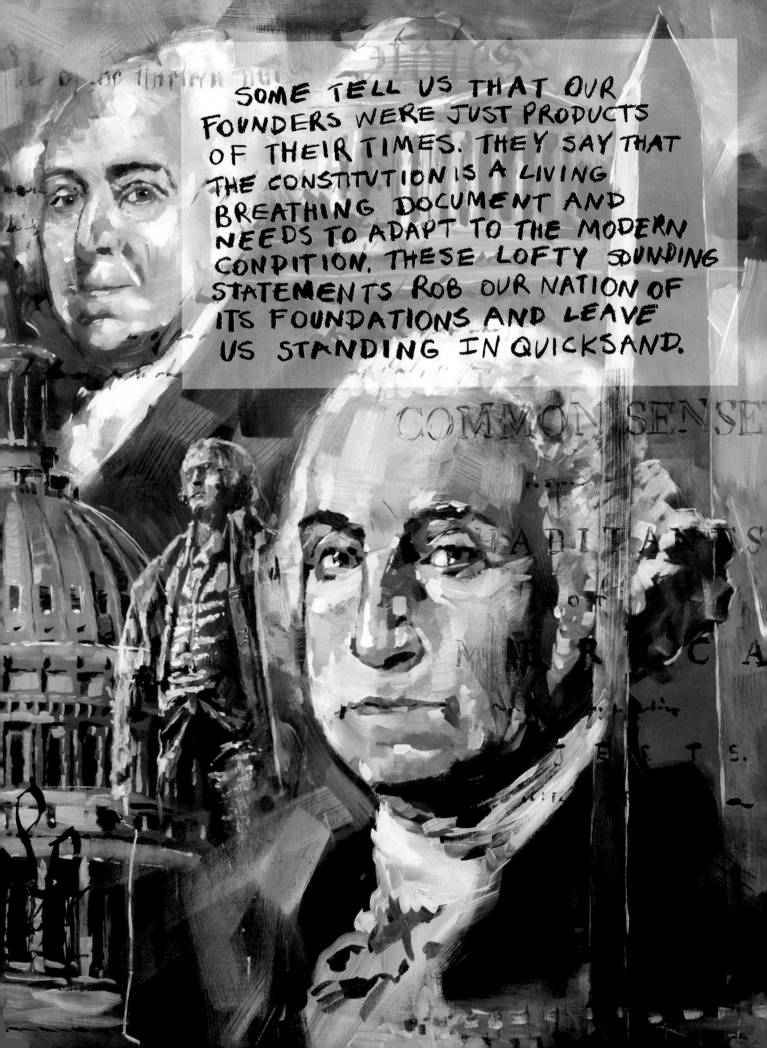

SOME TELL US THAT OUR FOUNDERS WERE JUST PRODUCTS OF THEIR TIMES. THEY SAY THAT THE CONSTITUTION IS A LIVING BREATHING DOCUMENT AND NEEDS TO ADAPT TO THE MODERN CONDITION. THESE LOFTY SOUNDING STATEMENTS ROB OUR NATION OF ITS FOUNDATIONS AND LEAVE US STANDING IN QUICKSAND.

WE LIVE IN WHAT MAY BE THE MOST PERILOUS
TIME IN THE HISTORY OF THE REPUBLIC.
DURING THE CIVIL WAR, AMERICA
SEEMED TO BE ON THE BRINK OF
COMING APART, BUT EVEN IN THOSE
DARK DAYS MOST AMERICANS SHARED
MANY COMMON VALUES. MOST AMERICANS
CLAIMED TO BELIEVE IN OUR FOUNDING
PRINCIPLES. BOTH SIDES SAID THAT
THEY WERE CARRYING OUT THE VISION
OF OUR FOUNDERS EVEN THOUGH ONE
SIDE IGNORED THE EVIL OF SLAVERY
IN ITS MIDST. FOR MOST OF OUR
NATION'S HISTORY THE COMMON BOND
OF FAITH AND BELIEF IN FREEDOM
WAS THE GLUE THAT HELD US
TOGETHER. OUR ANCESTORS
IN AMERICA WOULD HAVE BEEN
ASHAMED TO HAND OVER THEIR
FREEDOM AND RESPONSIBILITY
TO GOVERNMENT. THEY WOULD
NEVER DEPEND ON GOVERNMENT
FOR THEIR LIVELIHOOD.

EVEN DURING THE CIVIL WAR
OUR BELIEF IN LIBERTY FOR ALL
MEN, WHICH WAS THE MAIN ISSUE
OF THAT WAR, WOULD EVENTUALLY
BRING US BACK TOGETHER AGAIN.
REAGAN KNEW THAT A GOVERNMENT
THAT COULD TAKE CARE OF ITS
PEOPLE COULD ALSO ENSLAVE
THEM. THE COMMON BONDS WE
ALL SHARE ARE BEING DISMANTLED
BY TODAY'S POLITICIANS. THEY
KNOW THAT THEY CAN BECOME
MORE POWERFUL IF THEY CAN
PIT US AGAINST EACH OTHER.
THEY WANT US TO DIVIDE
OVER ISSUES OF RACE AND
INCOME AND WHATEVER
ELSE THEY CAN THINK OF.

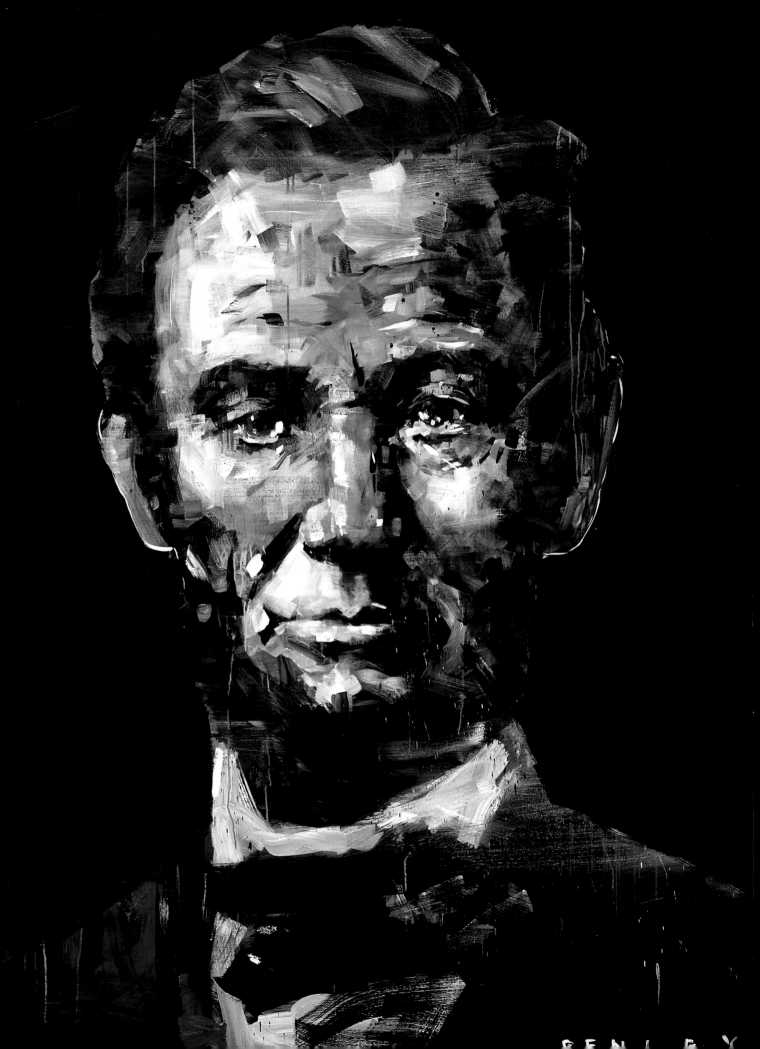

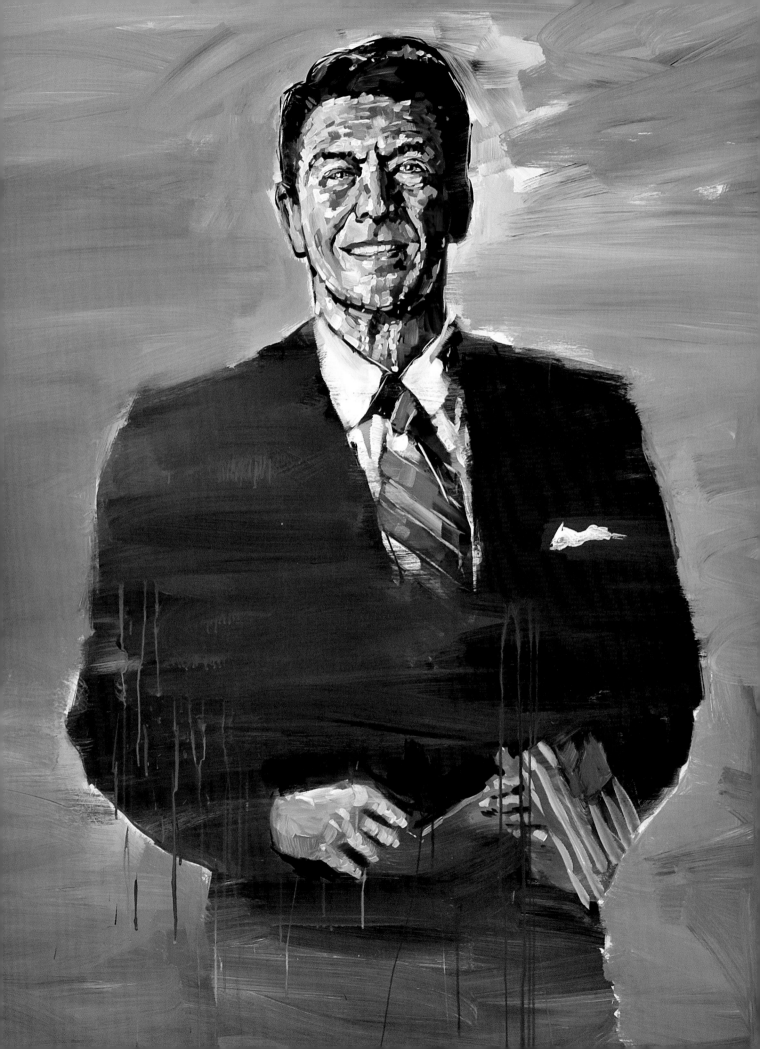

HOW DO WE PERSUADE A NEW
GENERATION OF AMERICANS TO
BELIEVE IN THE GREATNESS OF
AMERICA AND THE AMERICAN
IDEAL? IN THIS DAY OF CYNICISM
AND FEAR HOW DO WE EXPLAIN
TO OUR CHILDREN THAT WE ARE
ON THE WRONG PATH AND THAT
WE KNOW A BETTER WAY? WE DO
NOT HAVE TO LOOK FAR BACK
IN HISTORY TO FIND AN EXCELLENT
EXAMPLE FOR OUR CHILDREN
OF AMERICAN GREATNESS.
RONALD REAGAN IS A CHAMPION
OF THE AMERICAN IDEAL.

AS TIME HAS PASSED REAGAN'S IMAGE HAS GROWN IN POPULARITY. WHAT IS IT ABOUT THE MAN THAT RESONATES WITH SO MANY OF US? LIKE MANY OF OUR AMERICAN ICONS, REAGAN IS A REFLECTION OF US AND WHAT WE KNOW AMERICA CAN BE. REAGAN IS THE EMBODIMENT OF ALL THE HOPES AND DREAMS OF SO MANY AMERICANS. HE REPRESENTS THE KIND OF HOPE THAT IS MORE THAN AN EMPTY CAMPAIGN SLOGAN. HE REPRESENTS THE KIND OF HOPE THAT IS BASED IN PRINCIPLE AND REALITY AND NOT IN UTOPIAN FANTASY.

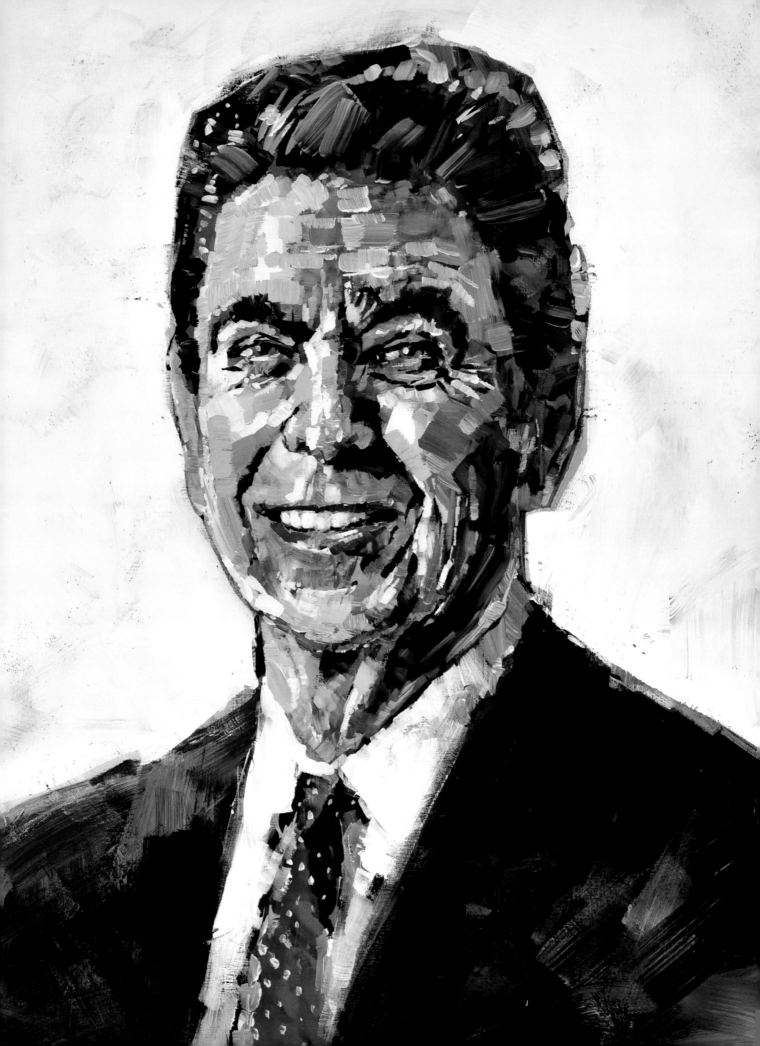

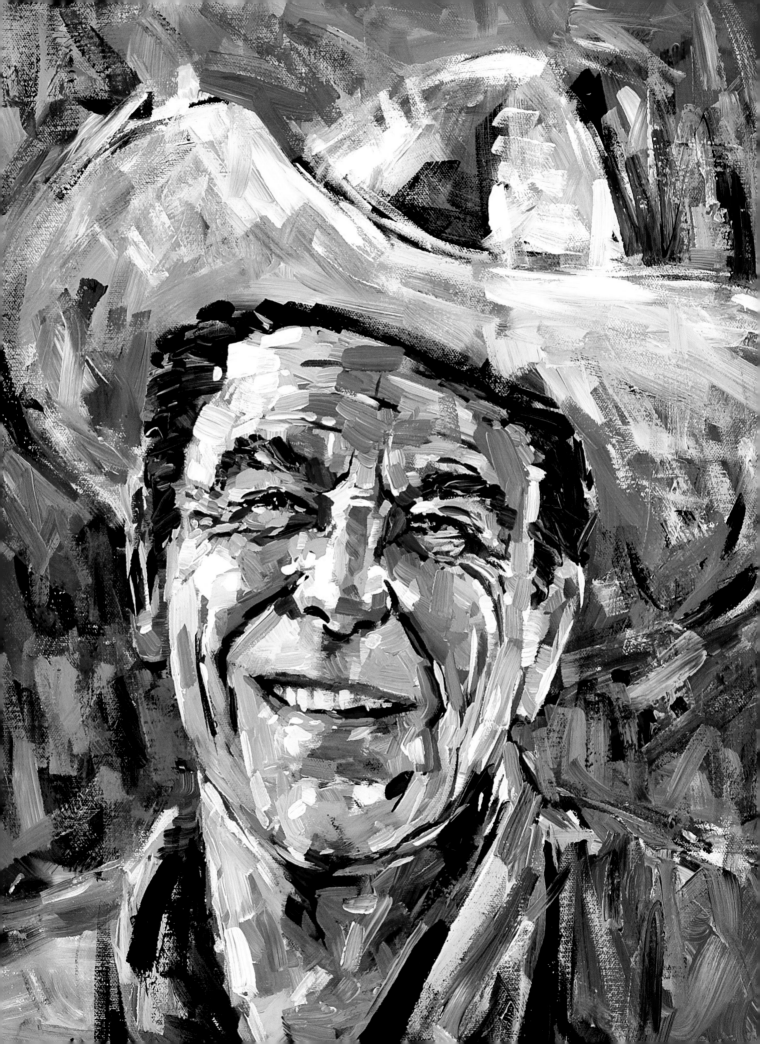

EVEN SOME OF REAGAN'S FORMER POLITICAL ENEMIES HAVE BEGUN TO SING HIS PRAISES. THERE ARE MANY BIOGRAPHIES ABOUT REAGAN WHICH TRY TO IMPLY THAT REAGAN WAS SUCCESSFUL SIMPLY BECAUSE OF HIS CHARISMA. THEY THINK THAT MARGINALIZING REAGAN'S LEGACY WILL WIN THEM FAVOR AMONG MEDIA ELITES, AND THEY ARE PROBABLY RIGHT, BUT THEY ARE IGNORING THE FACTS OF HISTORY. REAGAN'S WORDS SHINE A CONVICTING LIGHT ON TODAY'S RULING CLASS.

THEY KNOW THAT IF THEY CAN ERASE OUR HISTORY WE WILL NOT SEE THE DANGER OF AN ALL POWERFUL GOVERNMENT. REAGAN WAS A CHAMPION OF OUR FOUNDING PRINCIPLES. HE DID NOT THINK AMERICANS NEEDED A CENTRAL AUTHORITY KEEPING AN EYE ON EVERY ASPECT OF THEIR LIVES. REAGAN BELIEVED IN US.

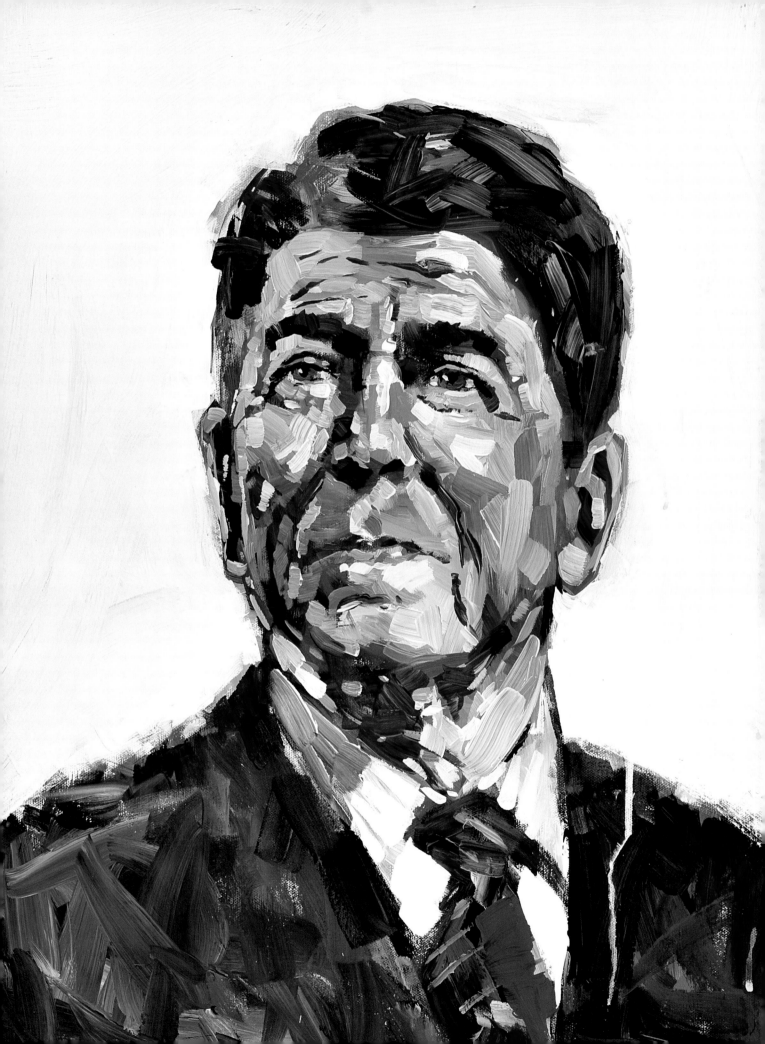

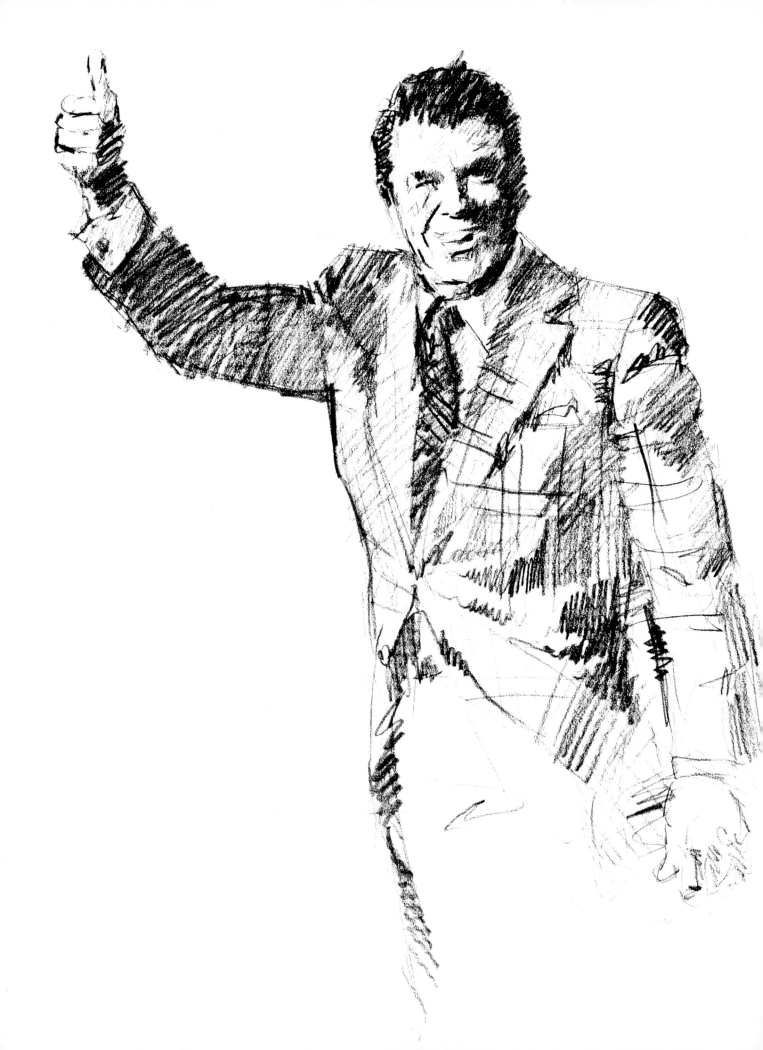

"If it moves, tax it. If it keeps moving, regulate it. If it stops moving, subsidize it."

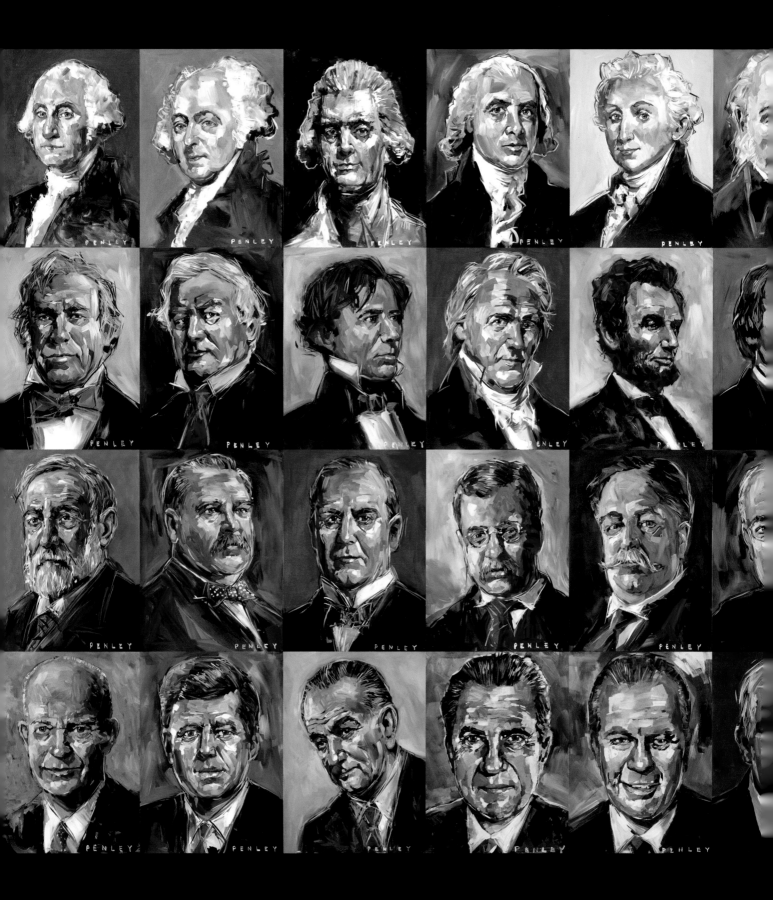

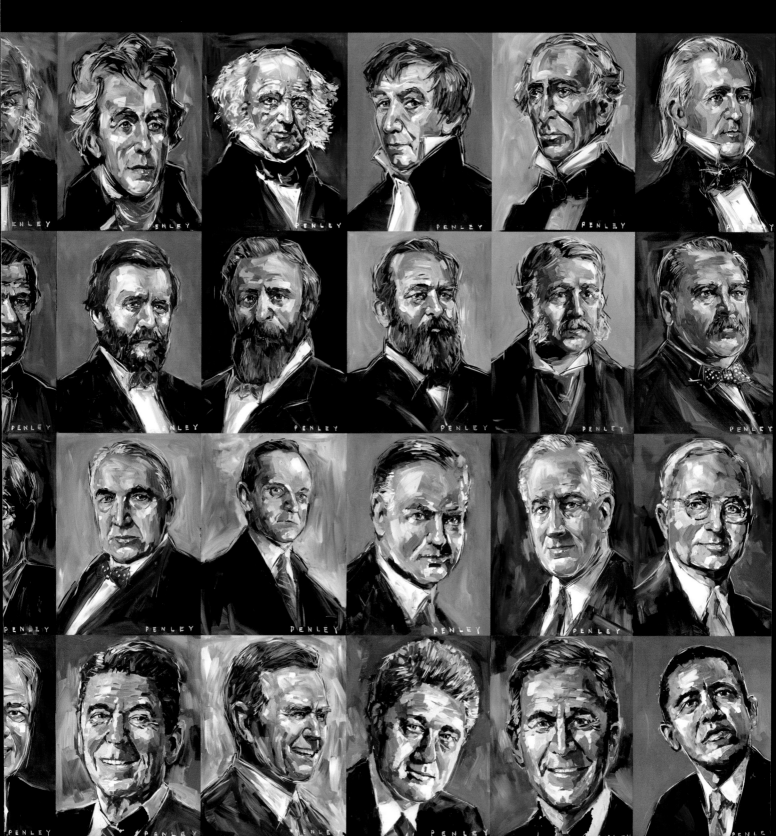

MANY YOUNG REPUBLICANS
TODAY CLAIM TO LOVE REAGAN
BUT REALLY DO NOT UNDERSTAND
WHAT HE REPRESENTED. SHALLOW
CONVICTIONS ARE EASILY BROKEN
SO NOW IS THE TIME TO REMEMBER
WHAT HE BELIEVED AND SAID.
AS WE WATCH OUR WEALTH
DWINDLE AND OUR FREEDOMS
FADE, AND AS WE WATCH THE
POLITICAL ESTABLISHMENT
MOCK OUR CHERISHED VALUES,
IS IT NOT TIME TO LOOK BACK
TO THE UNIQUE AMERICAN
CHARACTERISTICS THAT CAN
BRING US BACK TO GREATNESS?
REAGAN IS ONE OF THE MOST
ELOQUENT EXAMPLES OF
LEADERS WHO BELIEVED IN
THE AMERICAN IDEAL.

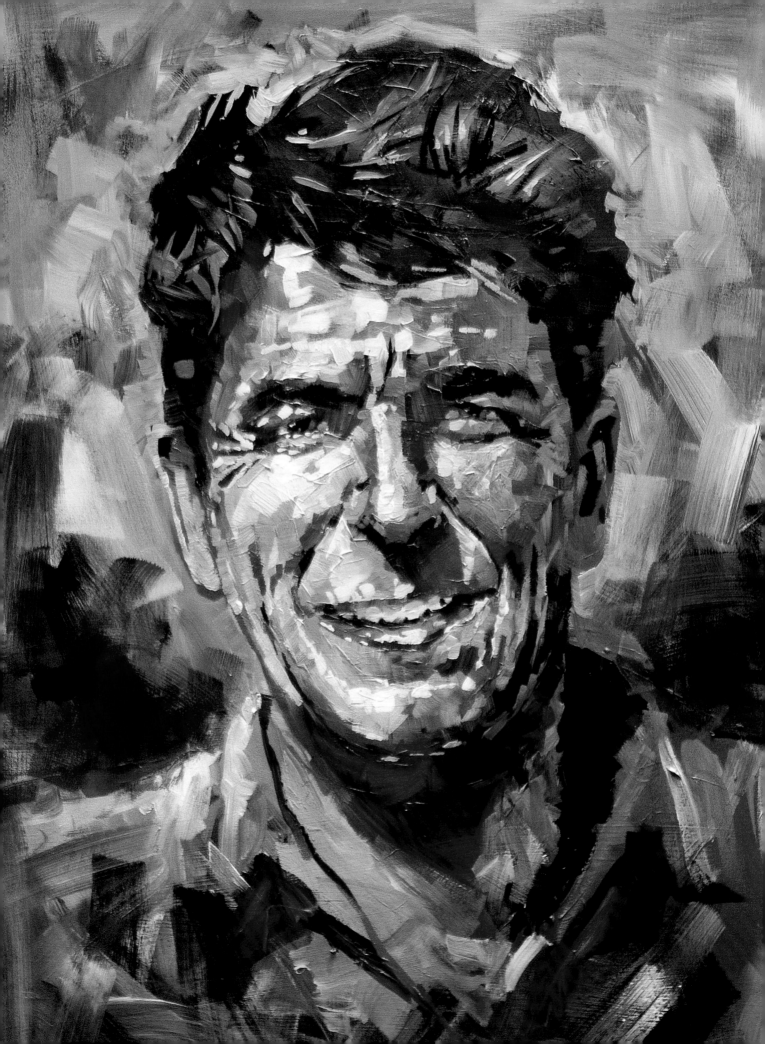

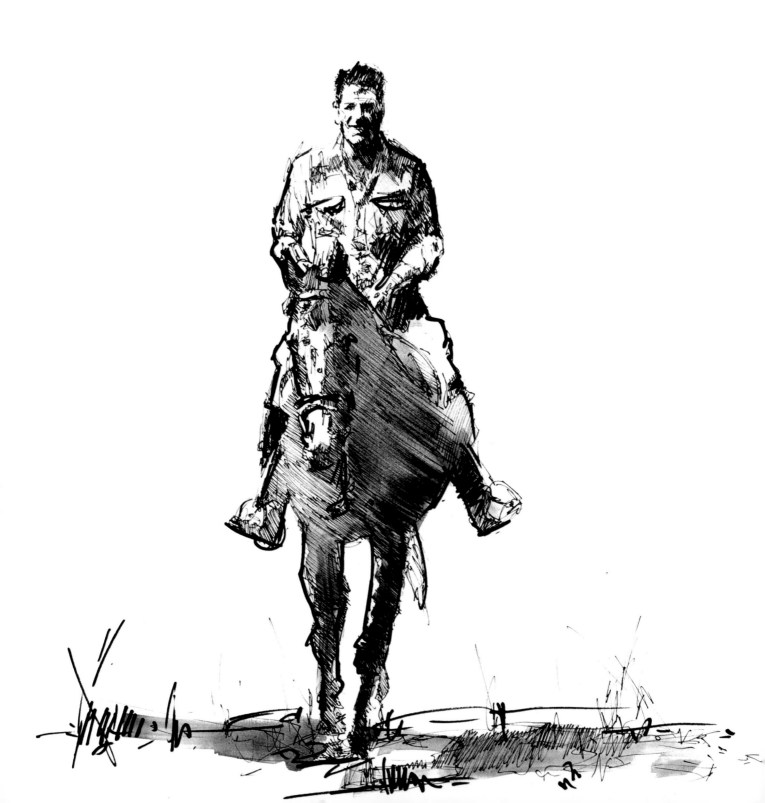

REAGAN WAS NOT AHEAD OF HIS TIME, REAGAN WAS TIMELESS.

REAGAN REFLECTED THE AMERICAN IDEAL BECAUSE HE ACTUALLY BELIEVED THAT THERE WAS AN AMERICAN IDEAL. TODAYS POLITICIAN WILL SEARCH FOR ANY STRATEGY WHICH HE OR SHE THINKS WILL CAPTURE THE MAJORITY OF VOTERS. REAGAN'S BELIEFS WERE BASED IN HIS UNWAVERING LOVE OF OUR COUNTRY AND AND ITS HISTORY. HE DID NOT WAIT FOR POLL RESULTS TO TELL HIM WHAT TO THINK.

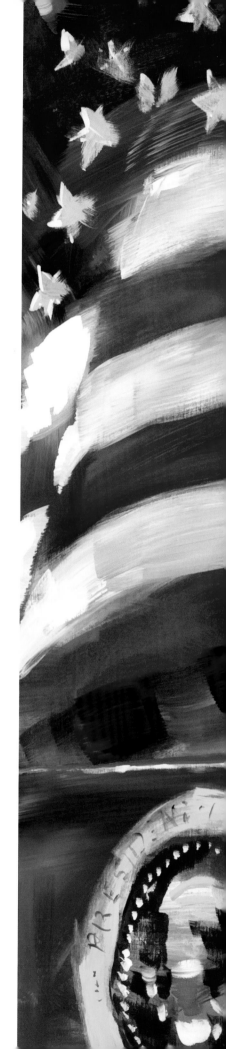

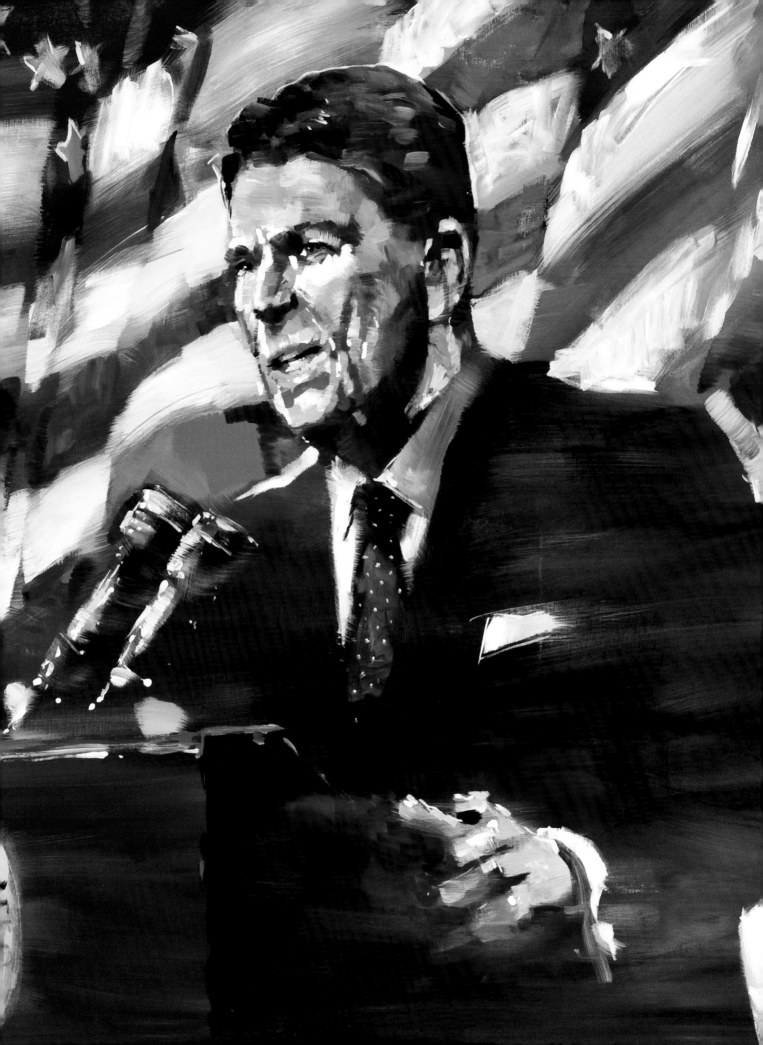

IN REAGAN'S AMERICA, ADVERSITY ONLY MADE US STRONGER, AND COMPETITION ONLY MADE US BETTER.

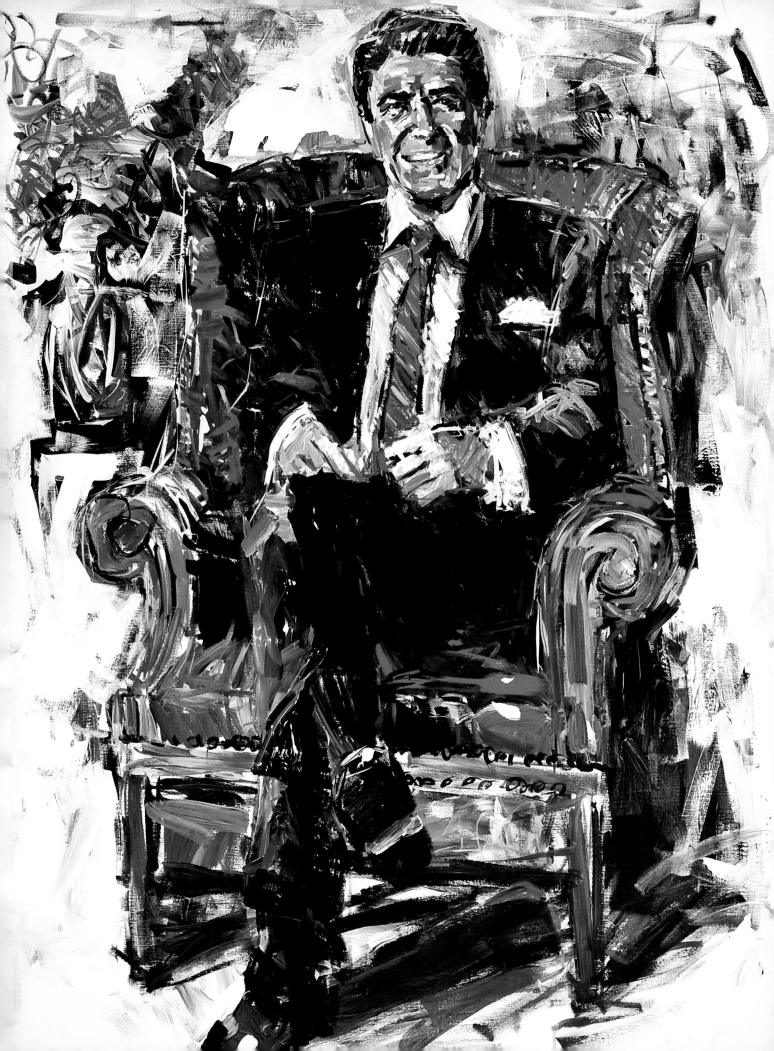

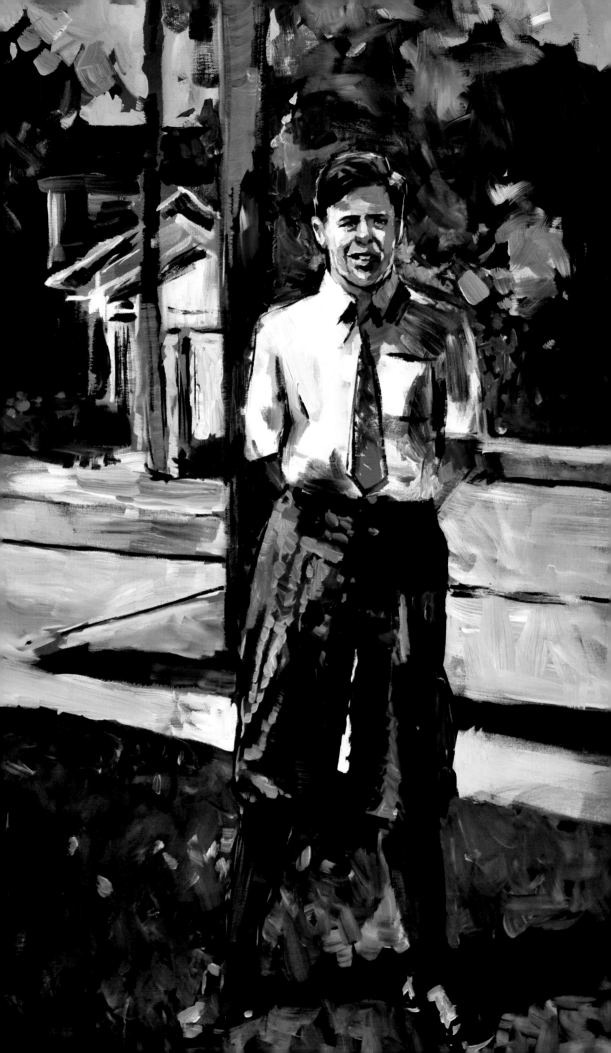

REAGAN SAW IN DIXON THAT
THE BEST PEOPLE FOR
SOLVING PROBLEMS WERE
THE ORDINARY PEOPLE WHO
WERE CLOSEST TO THE
PROBLEMS, HOW COULD A
BUREAUCRACY HUNDREDS
OF MILES AWAY UNDERSTAND
THE NEEDS OF A TOWN AND
ITS PEOPLE.

WITH REAGAN WE CREATED
ANEW THAT SHINING CITY
ON A HILL.

HIS MOTHER TAUGHT HIM
HOW SEEMINGLY RANDOM
TWISTS OF FATE ARE ALWAYS
USED BY GOD FOR THE
GREATER GOOD,

FROM LIFEGUARD, TO RADIO,
TO HOLLYWOOD; THESE WERE
ALL STEPPING STONES TO THE
WHITE HOUSE. EVEN THROUGH
HIS REJECTIONS, HE NEVER
DOUBTED HIMSELF.

SETBACKS WERE JUST
A PART OF PROVIDENCE.

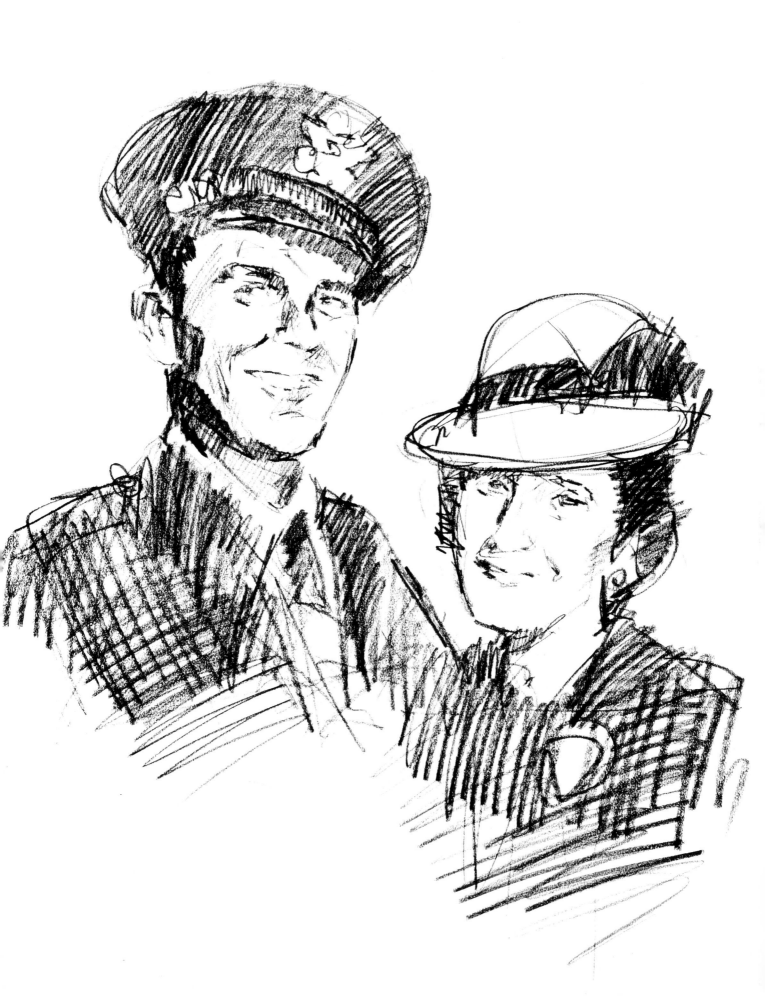

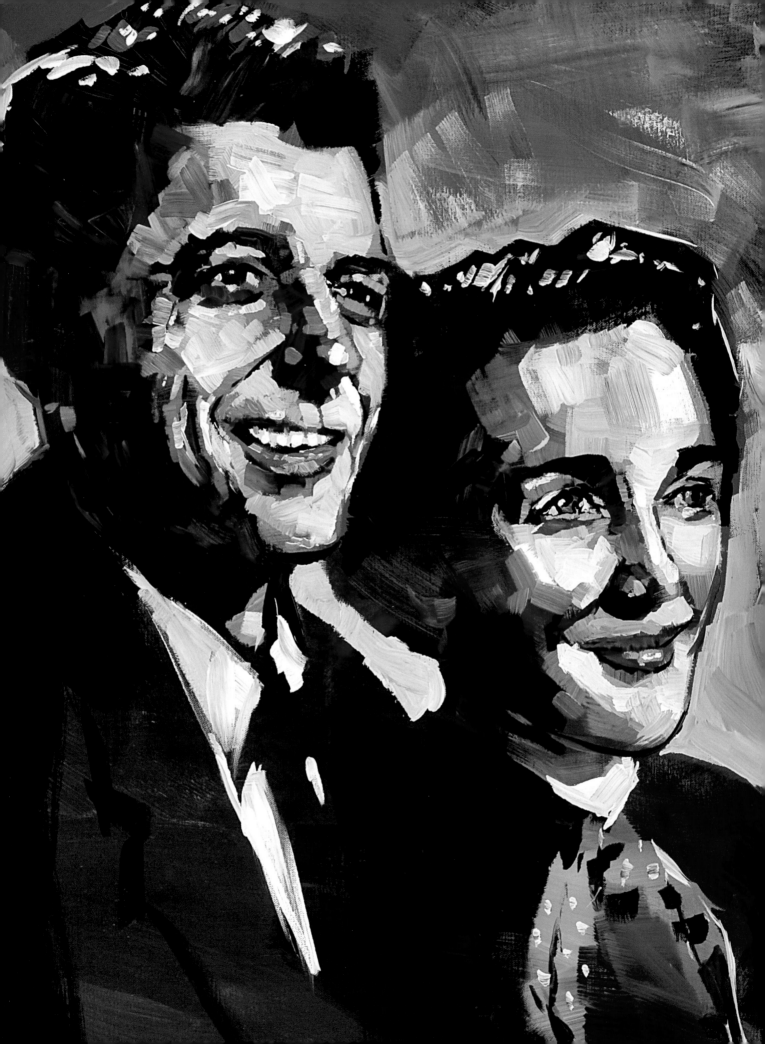

"IN THIS TWO - HUNDREDTH ANNIVERSARY YEAR OF OUR CONSTITUTION, YOU AND I STAND ON THE SHOULDERS OF GIANTS - MEN WHOSE WORDS AND DEEDS PUT WIND IN THE SAILS OF FREEDOM..."

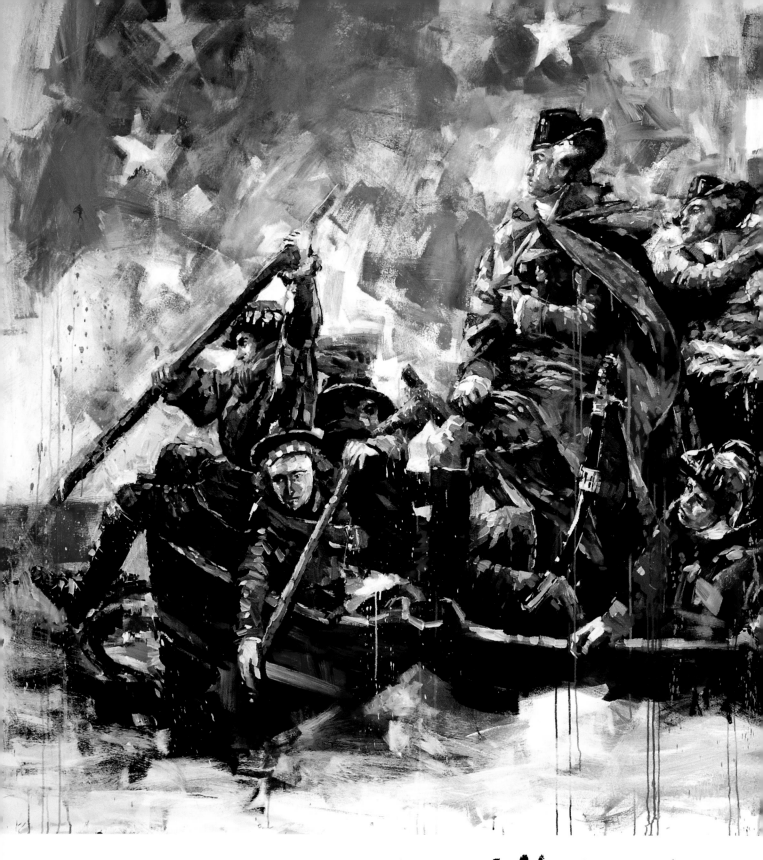

REAGAN INVISIONED AN AMERICA UNDER A BANNER OF BOLD COLORS AND NOT A PALETTE OF PALE PASTELS.

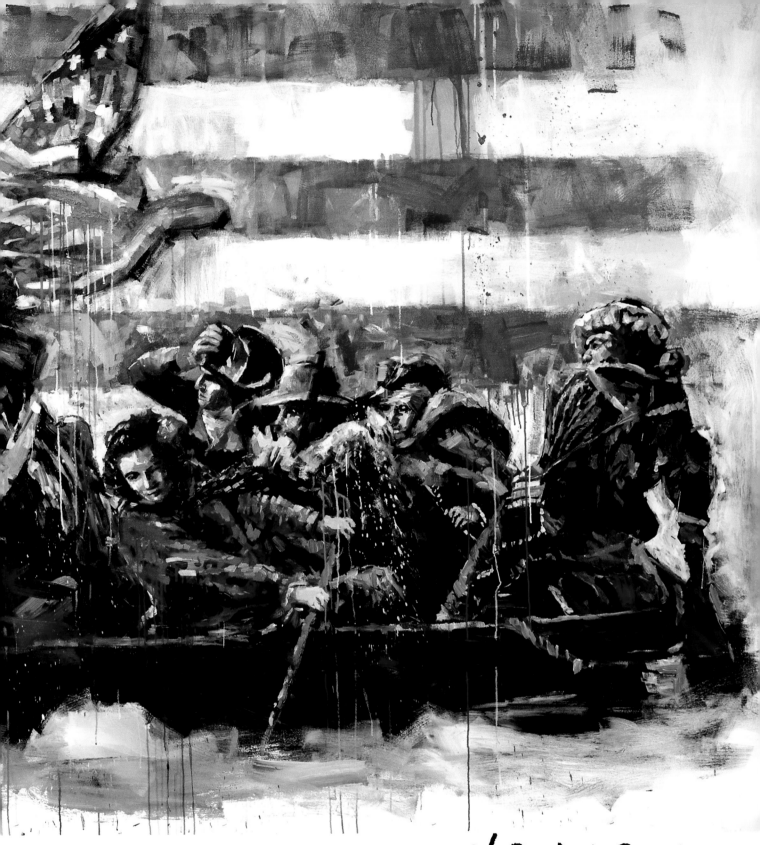

"A NATION AS YOUNG AS AMERICA CAN DREAM AS BIG AS THE WORLD."

"WITH GOD'S HELP

THERE IS NO LIMIT TO WHAT MEN CAN ACCOMPLISH."

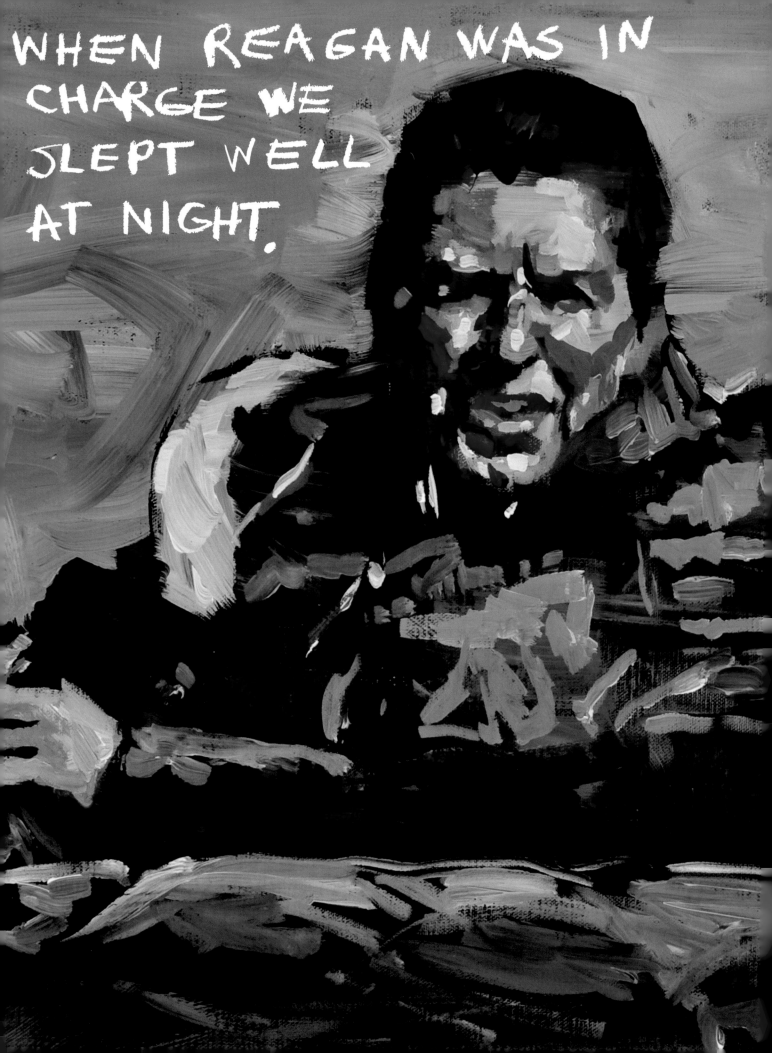

WHEN REAGAN WAS IN CHARGE WE SLEPT WELL AT NIGHT.

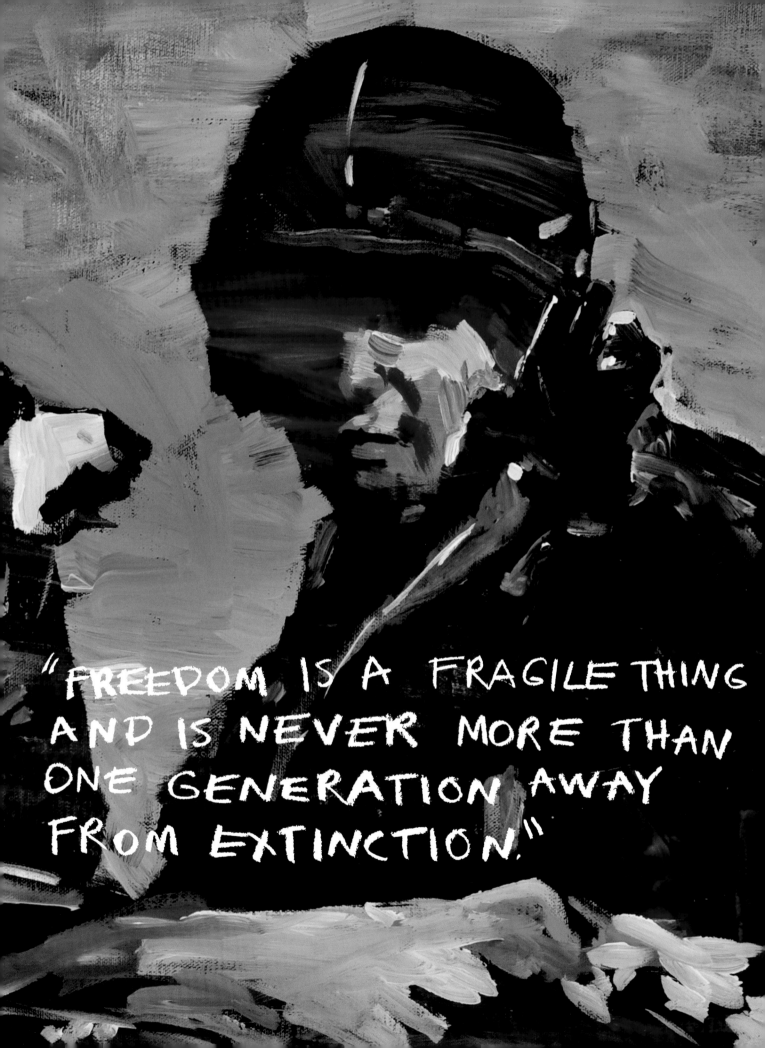

"FREEDOM IS A FRAGILE THING AND IS NEVER MORE THAN ONE GENERATION AWAY FROM EXTINCTION."

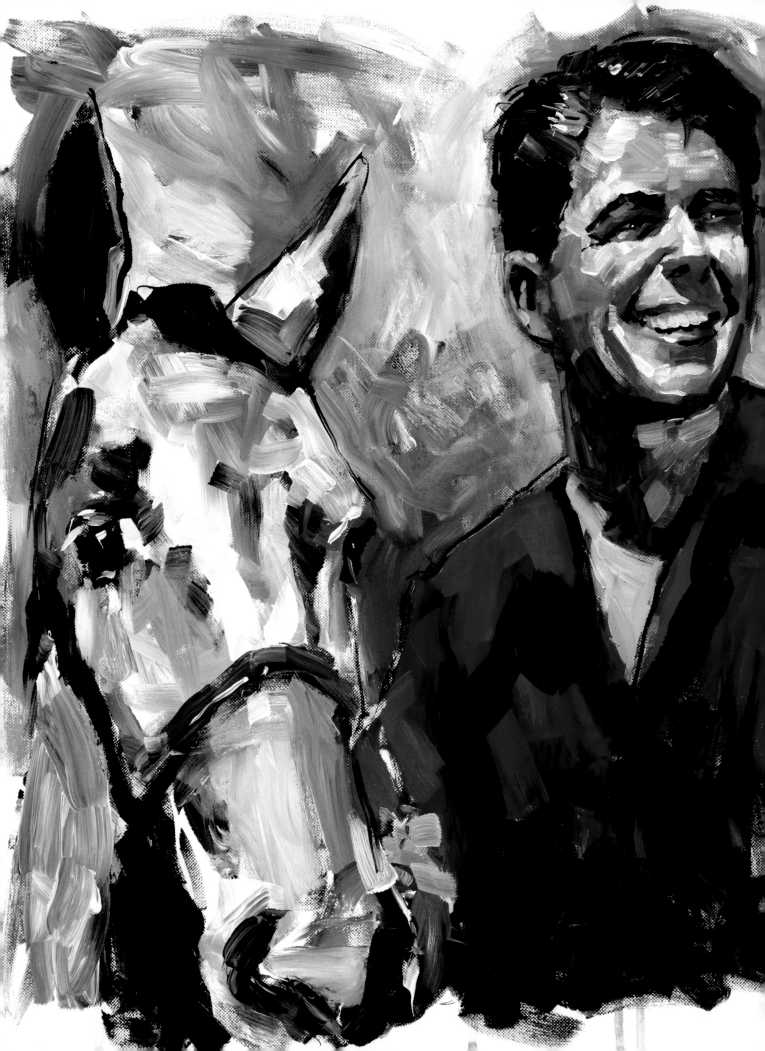

"ALL GREAT CHANGE IN AMERICA BEGINS AT THE DINNER TABLE."

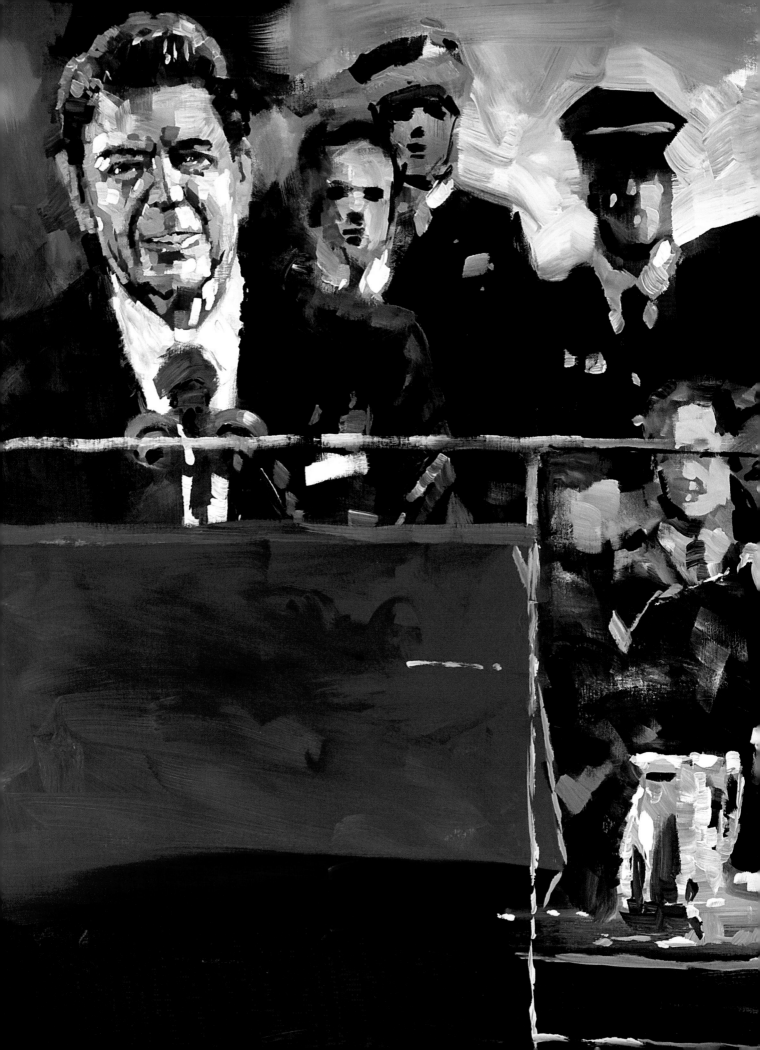

I WON A NICKNAME, "THE GREAT COMMUNICATOR." BUT I NEVER THOUGHT IT WAS MY STYLE OR THE WORDS I USED THAT MADE A DIFFERENCE: IT WAS THE CONTENT. I WASN'T A GREAT COMMUNICATOR, BUT I COMMUNICATED GREAT THINGS, AND THEY DIDN'T SPRING FULL BLOOM FROM MY BROW, THEY CAME FROM THE HEART OF A GREAT NATION—FROM OUR EXPERIENCE, OUR WISDOM, AND OUR BELIEF IN THE PRINCIPLES THAT HAVE GUIDED US FOR TWO CENTURIES.

RONALD REAGAN'S FAREWELL ADDRESS, JANUARY 11, 1989

GREAT LEADERS DO NOT
LEAD FROM THE PACK.

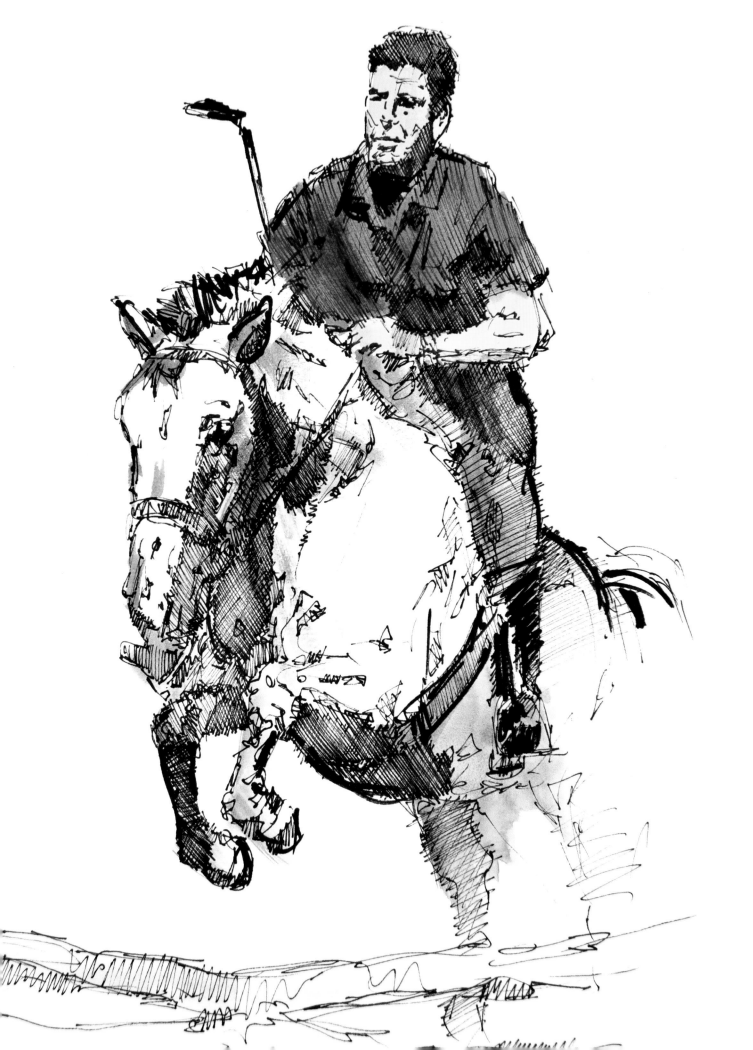

"HOW DO YOU TELL A COMMUNIST? WELL, IT'S SOMEONE WHO READS MARX AND LENIN. AND HOW DO YOU TELL AN ANTI-COMMUNIST? IT'S SOMEONE WHO UNDERSTANDS MARX AND LENIN."

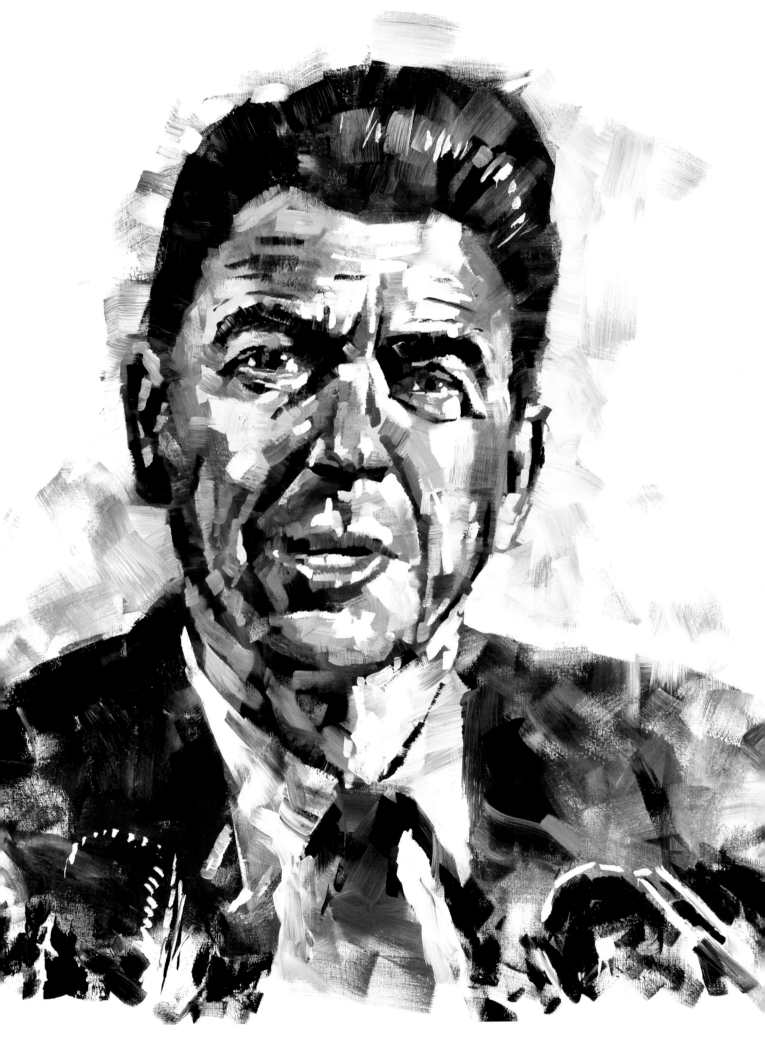

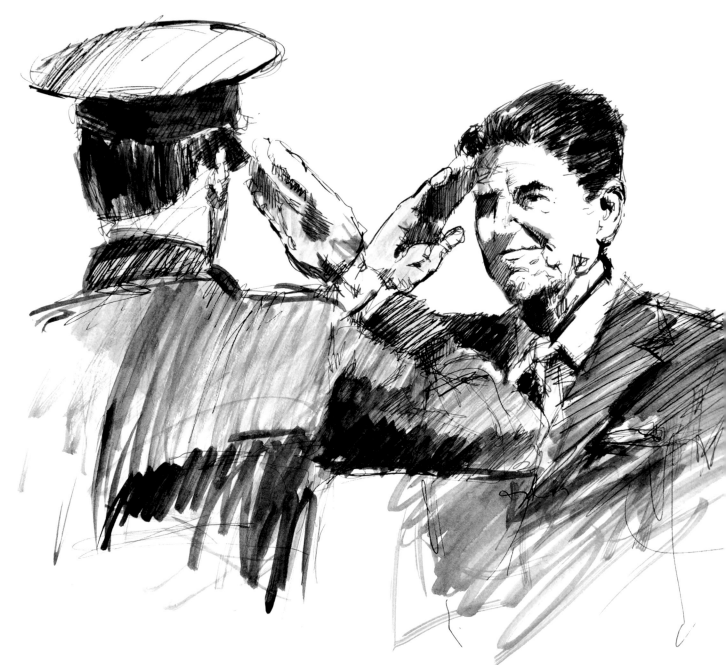

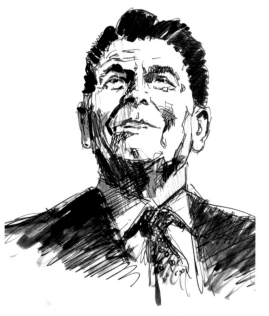

"REPUBLICANS
BELIEVE EVERY
DAY IS THE FOURTH
OF JULY, BUT THE
DEMOCRATS
BELIEVE EVERY
DAY IS APRIL 15TH."

"GOVERNMENT ALWAYS FINDS A NEED FOR WHATEVER MONEY IT GETS."

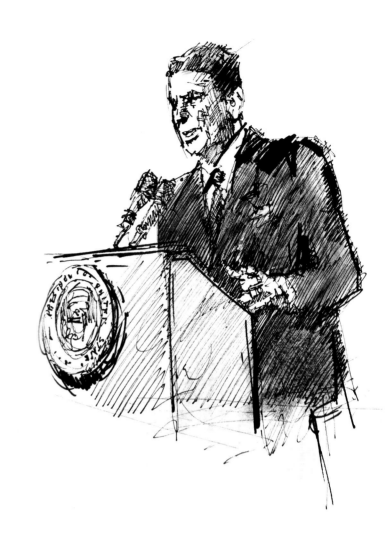

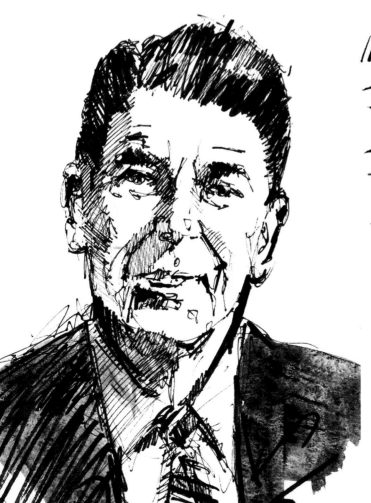

"DEMOCRACY IS WORTH DYING FOR, BECAUSE IT'S THE MOST DEEPLY HONORABLE FORM OF GOVERNMENT EVER DEVISED BY MAN."

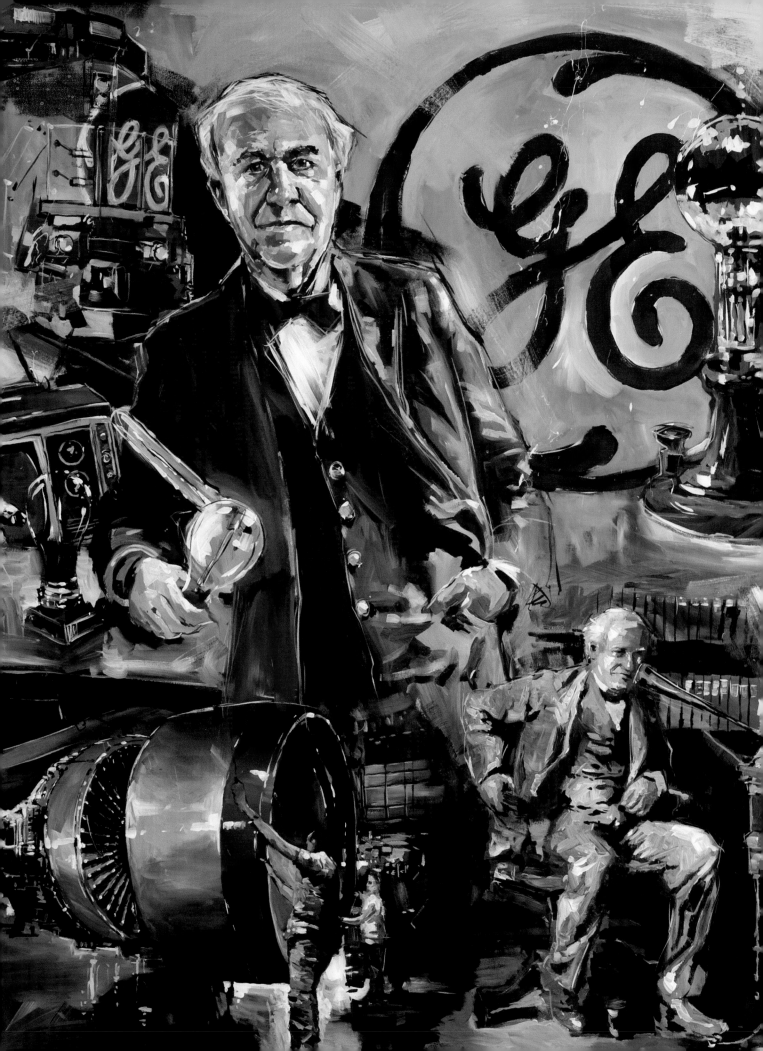

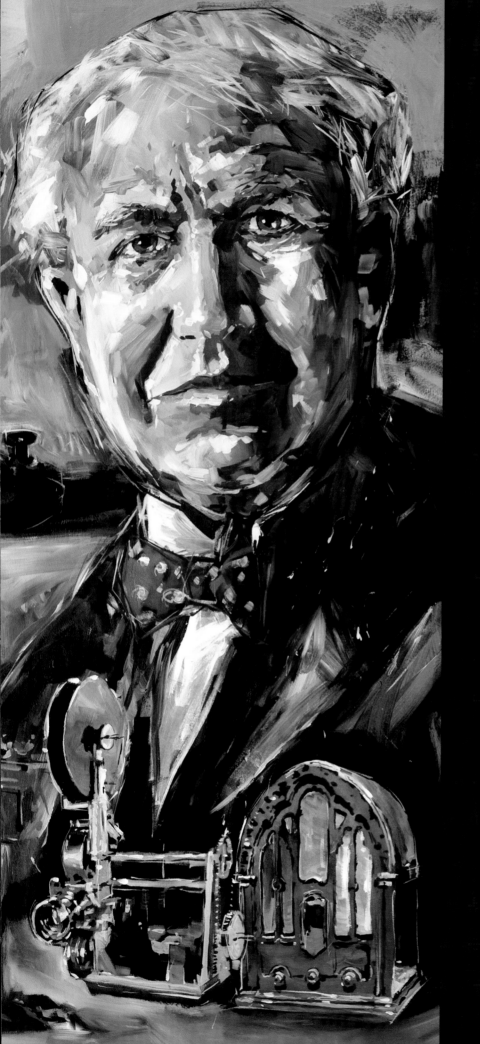

REAGAN
RECOGNIZED
THAT THE
UNLEASHED
POWER OF
INVENTORS
AND
CAPITALISTS
EASED
THE LIVES
OF MEN
AND WOMEN
ALL
AROUND
THE WORLD.
HE DID
ALL HE
COULD TO
GET
GOVERNMENT
OUT OF
THEIR
WAY.

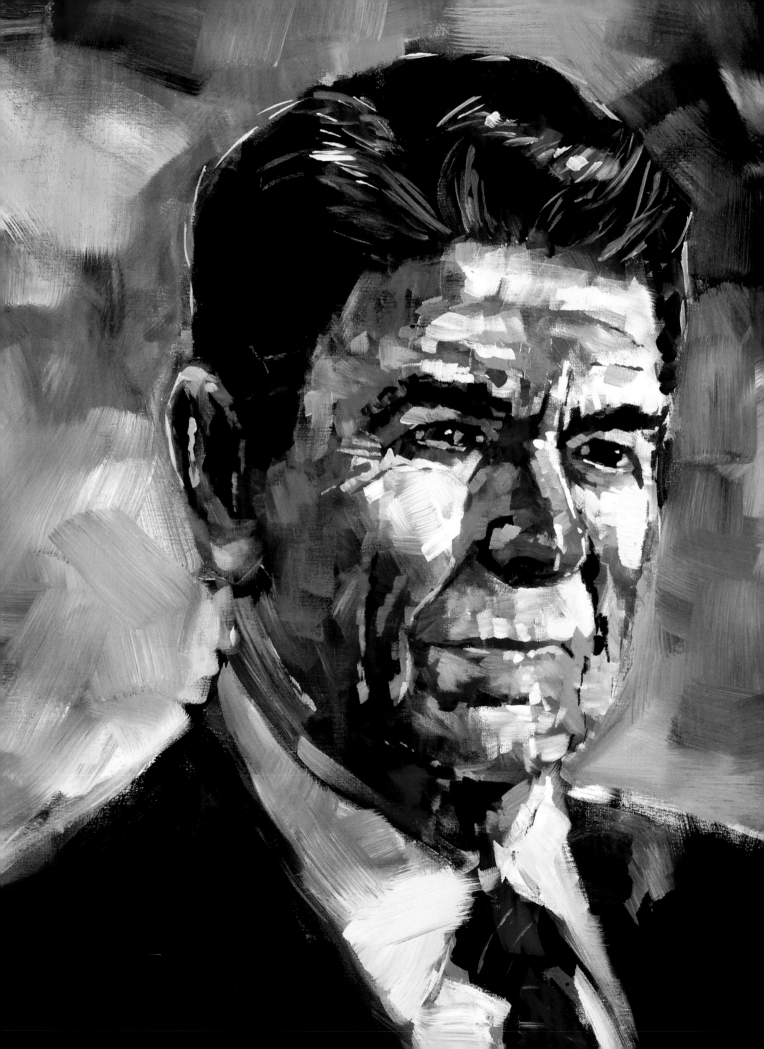

HIS IDEA OF STIMULUS
WAS TO GIVE OUR MONEY
BACK TO US. HE DID NOT
THROW GOOD MONEY AFTER
BAD.

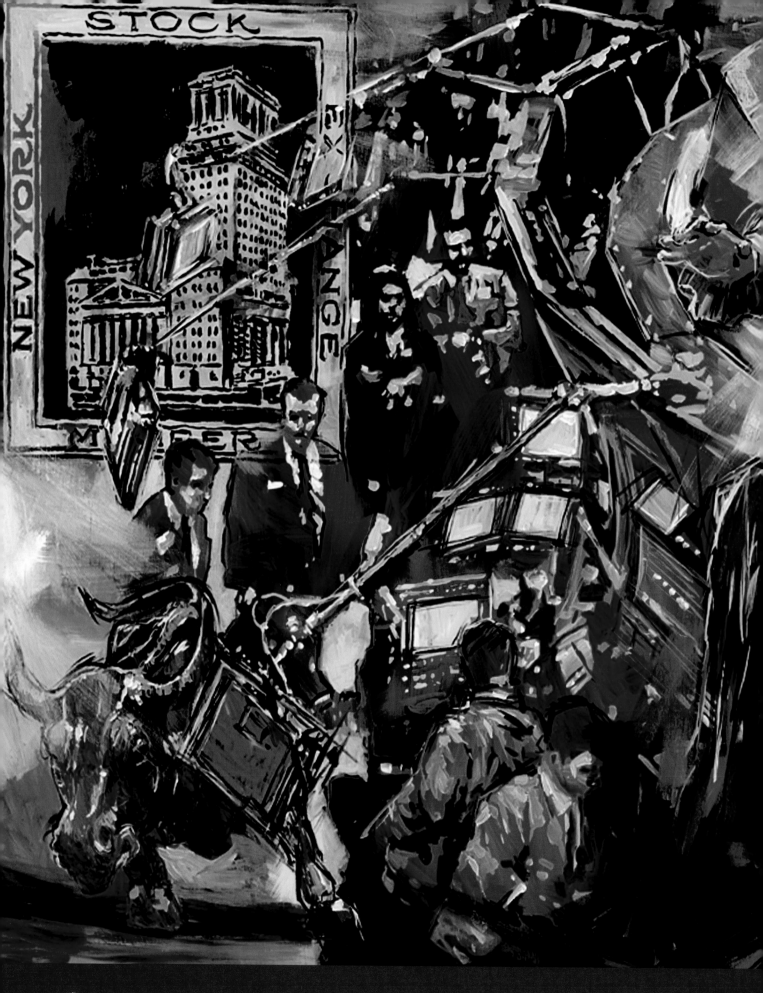

REAGAN UNLEASHED THE

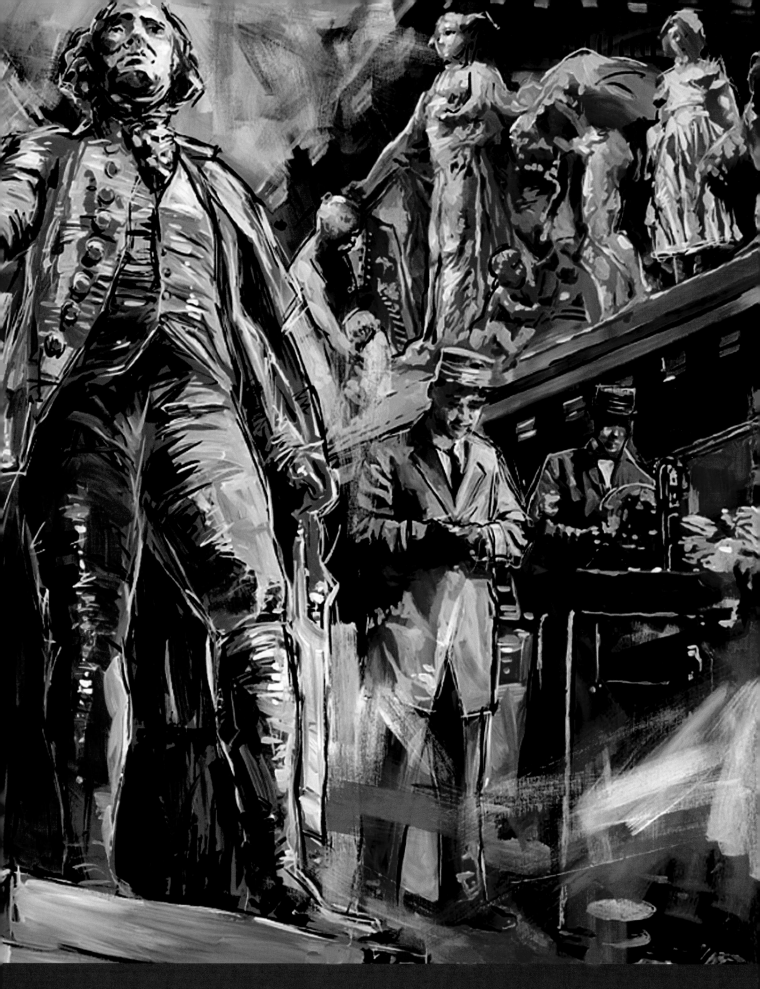

GENIUS OF AMERICA,

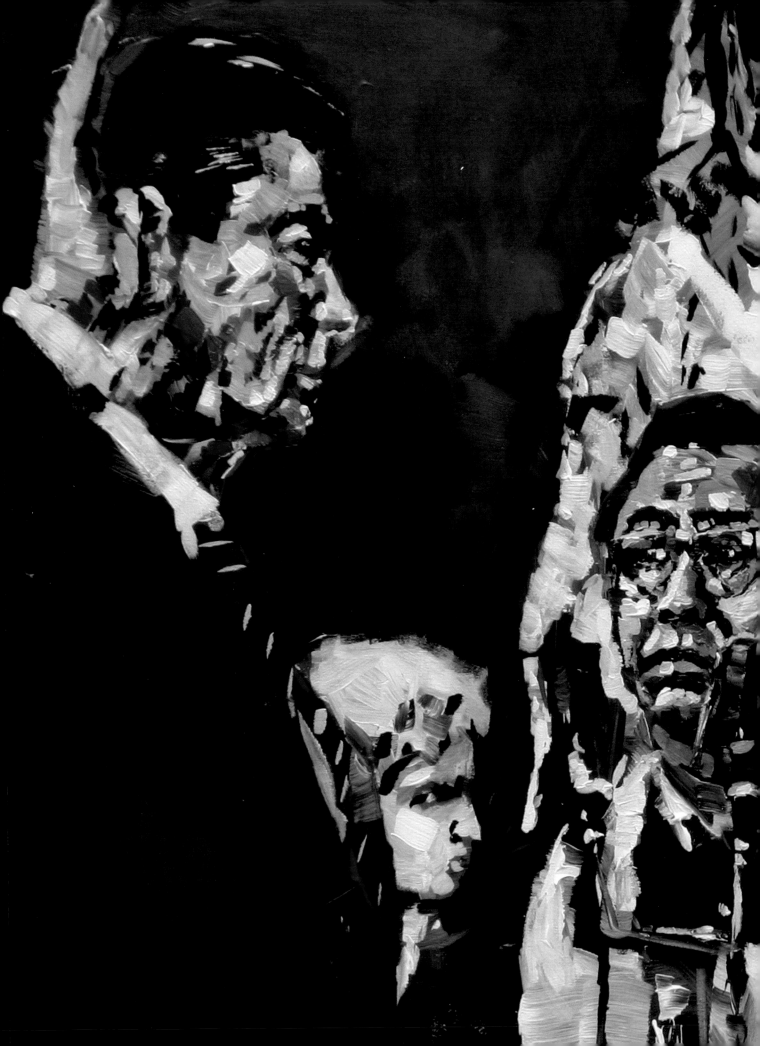

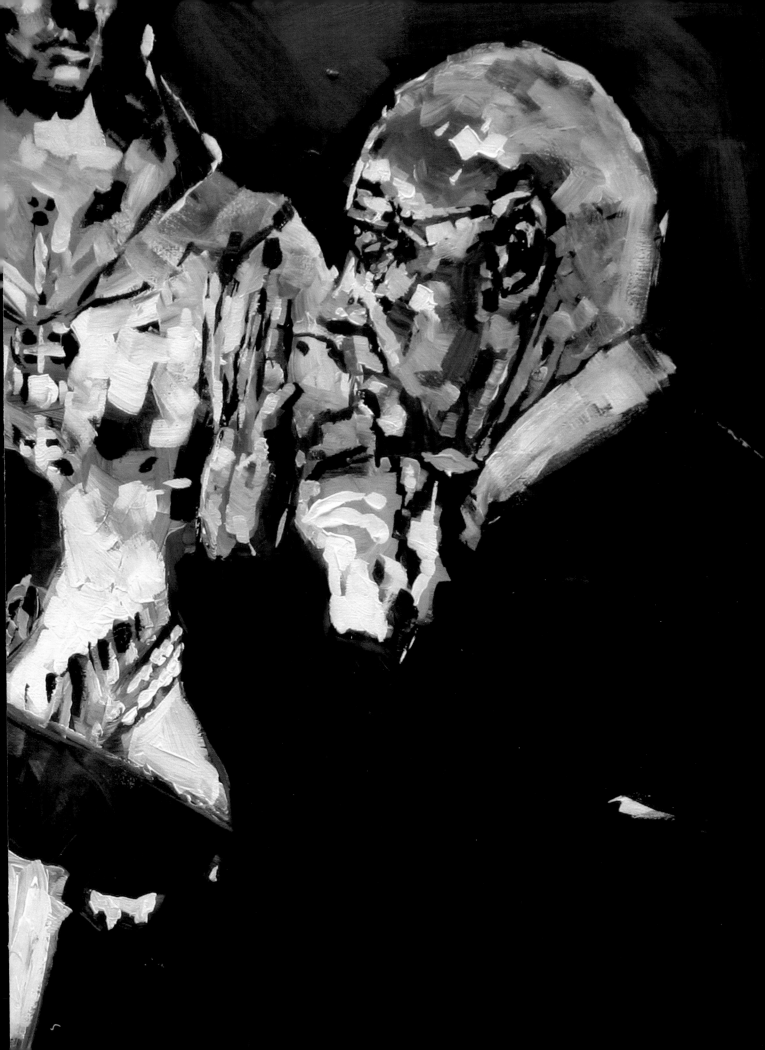

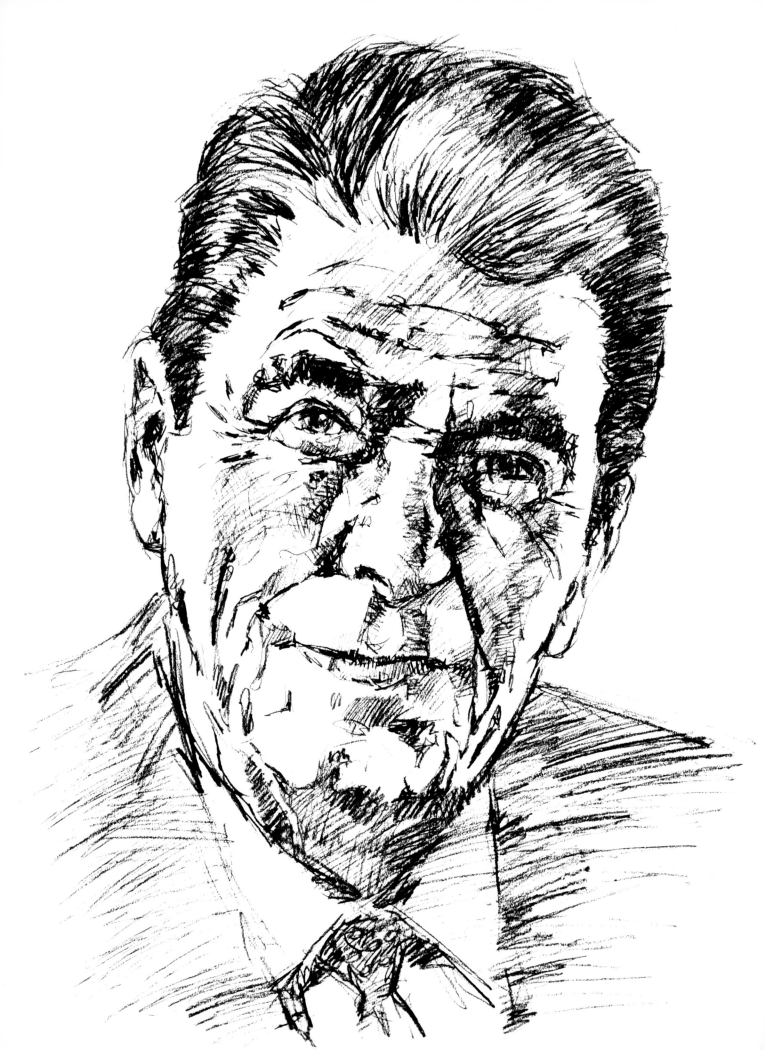

"YOU CAN TELL A LOT ABOUT A FELLOW'S CHARACTER BY HIS WAY OF EATING JELLYBEANS."

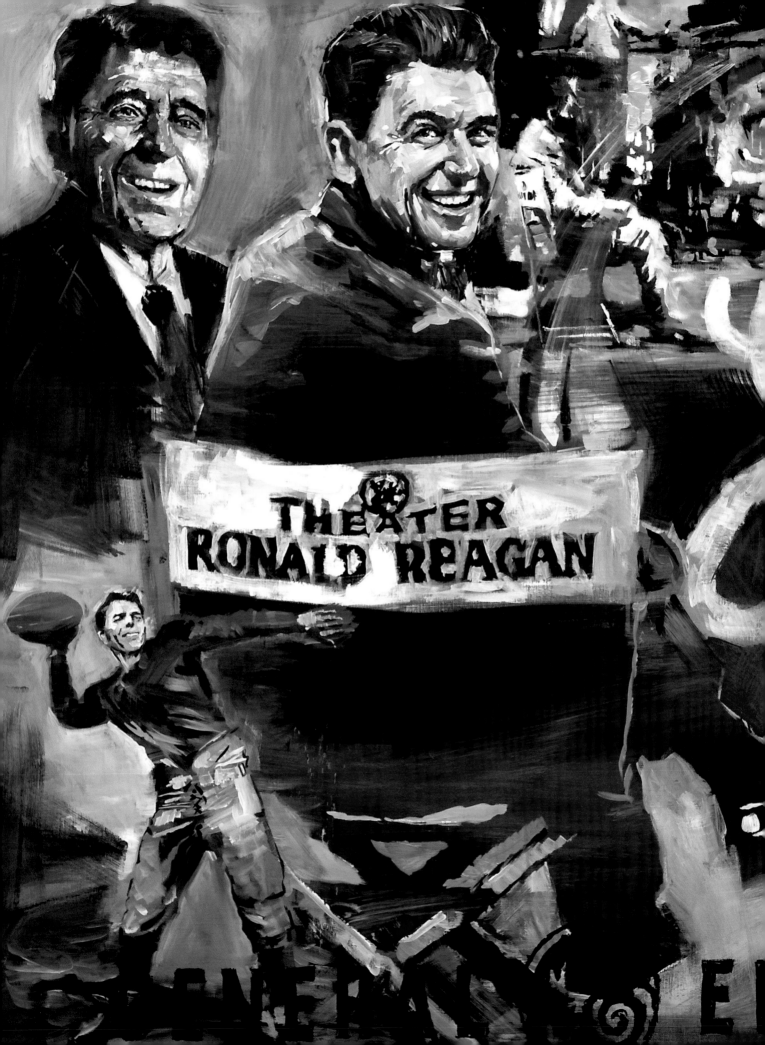

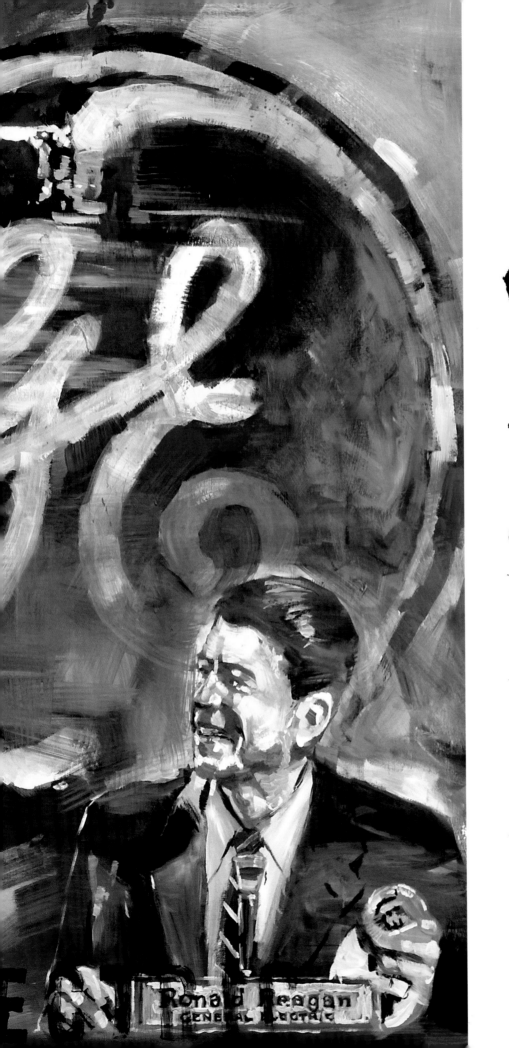

Ronald Reagan
GENERAL ELECTRIC

REAGAN'S LIFE REFLECTS THE POTENTIAL OF THE HUMAN SPIRIT, AS GOD'S CREATURES THERE ARE NO LIMITS TO WHAT WE CAN ACHIEVE IF WE ARE SET FREE TO BE OUR BEST.

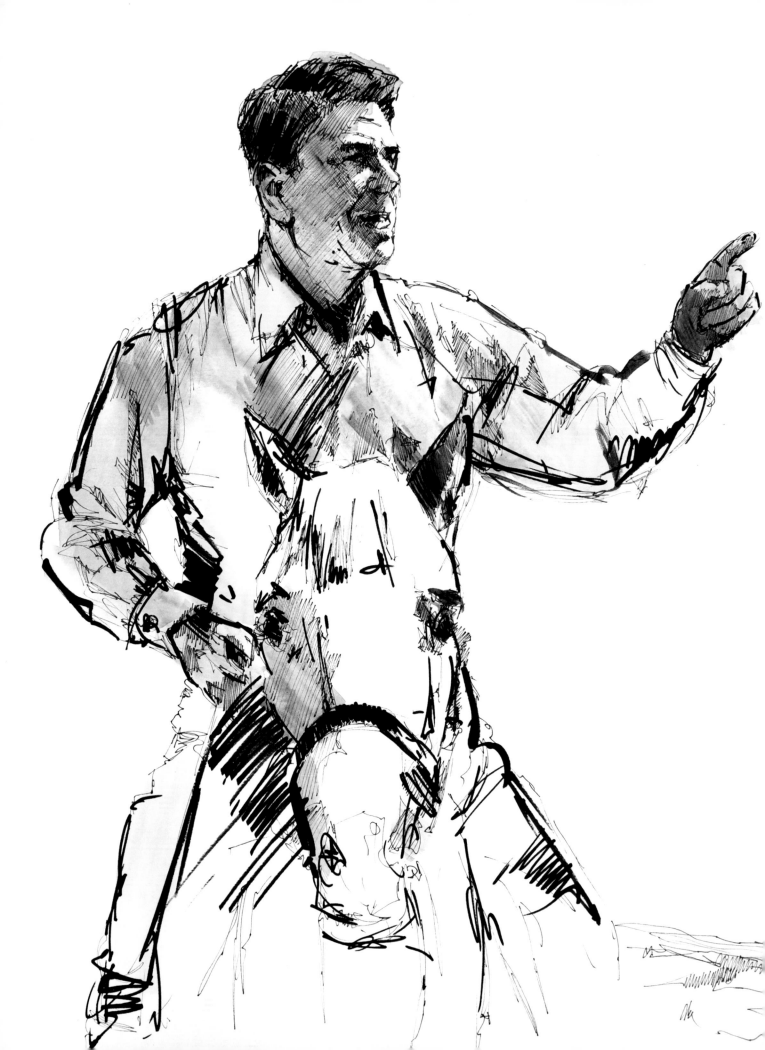

IN AN AGE OF SO MUCH MORAL AND CULTURAL AMBIGUITY, REAGAN PORTRAYED AN UNCHANGING IMAGE OF STRENGTH AND PRIDE.

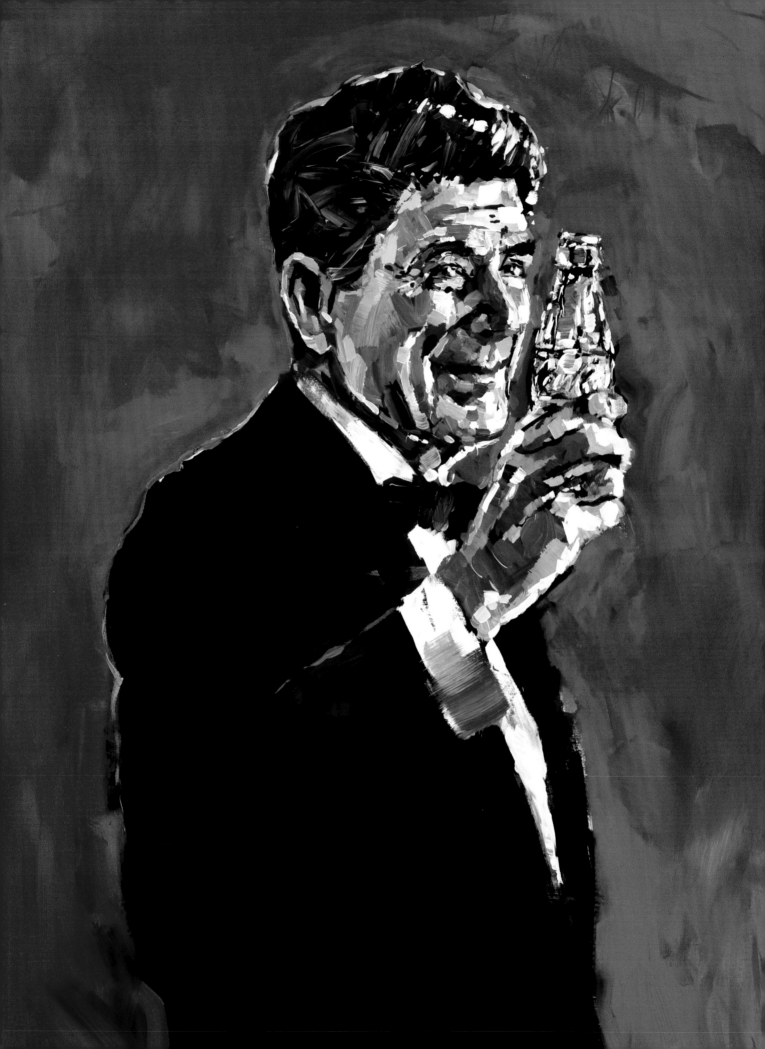

"THE TASK THAT HAS FALLEN TO US AMERICANS IS TO MOVE THE CONSCIENCE OF THE WORLD — TO KEEP ALIVE THE HOPE AND DREAM OF FREEDOM."

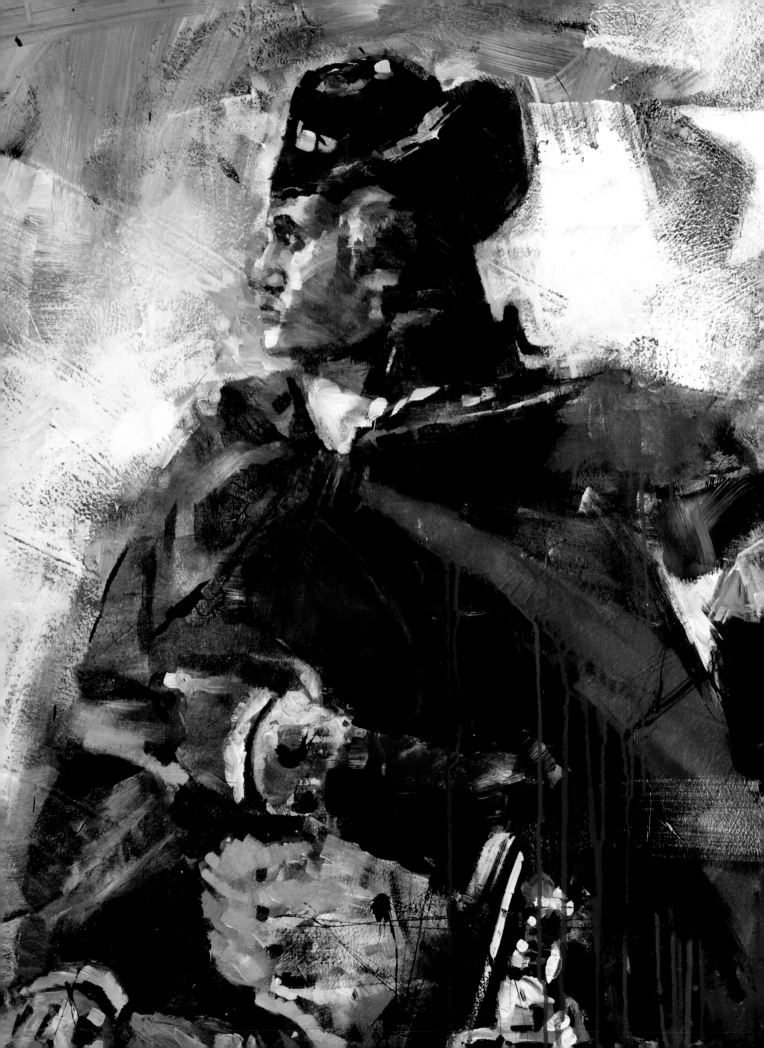

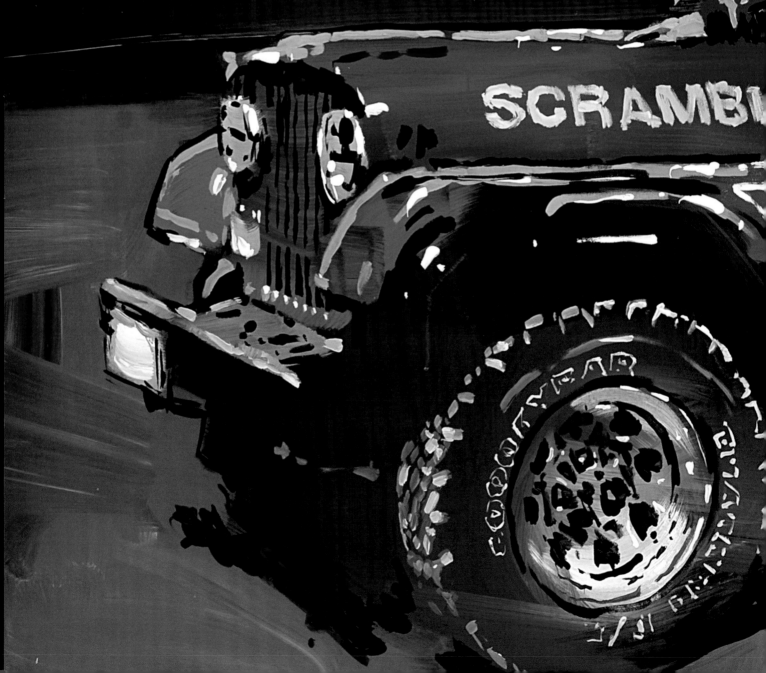

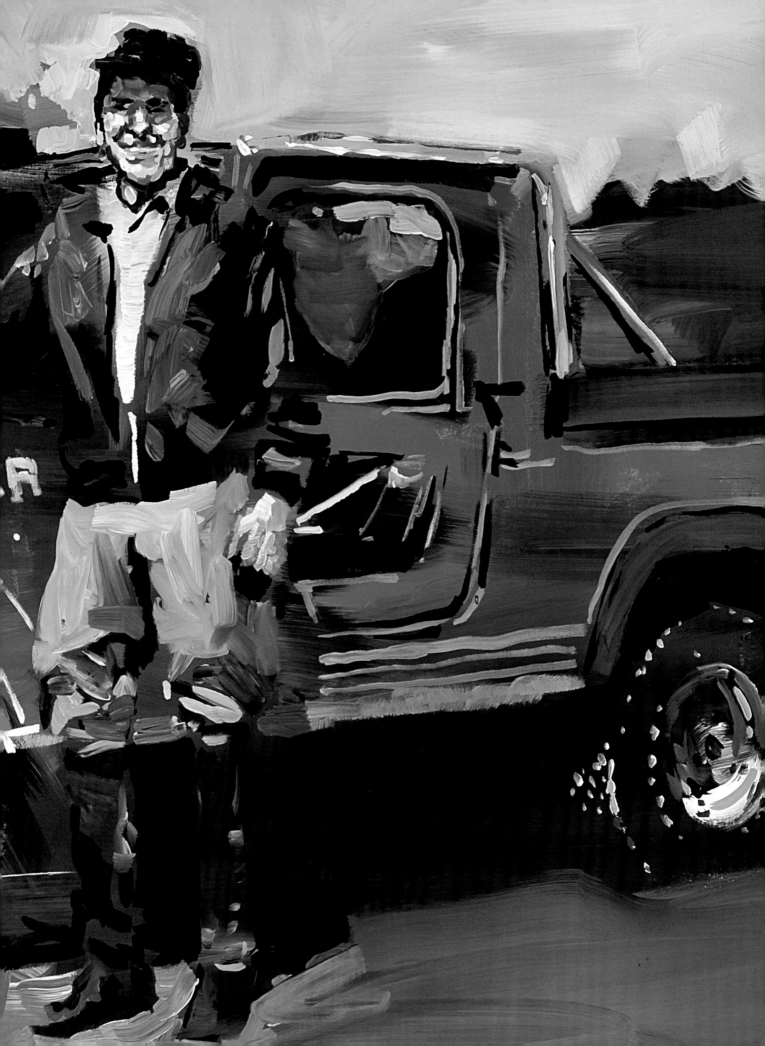

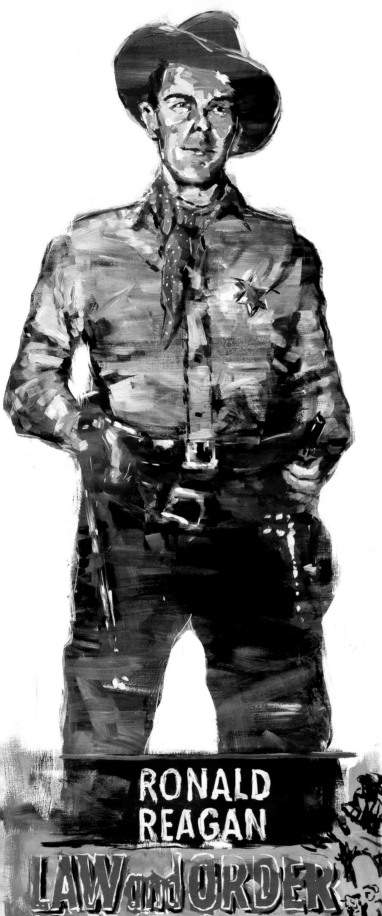

RONALD
REAGAN

LAW and ORDER

COLOR BY TECHNICOLOR

DOROTHY MALONE · PRESTON FOSTER

ALEX NICOL RUTH HAMPTON

THE WESTERNS THAT
WE WATCHED AS KIDS
OFFERED US HEROIC
IDEALS, AND THOSE
IDEALS WERE IMPRINTED
IN OUR MINDS FOREVER.
THE ELITES PULL FOR
DIFFERENT KINDS
OF HEROES. THEY ARE
MORE COMFORTABLE
WITH THOSE THAT ARE
FLAWED AND REBELLIOUS.
THEY LIKE THOSE WHO
NEVER DEFINE GOOD
VS. EVIL, AND THOSE
THAT NEVER TAKE
A STAND. THE WESTERN
HEROES WERE NOT
TROUBLED AND DEVIANT.
THEY WERE WHAT WE WISHED
WE COULD BE.

REAGAN WAS IN PERFECT
CHARACTER IN HIS PORTRAYALS
OF COWBOYS, WAR HEROES, AND
FOOTBALL STARS. HE WAS
ALL OF THOSE THINGS AND
MORE.

EVEN THOUGH REAGAN
MAY NOT HAVE BEEN
CONSIDERED AN
INTELLECTUAL, HIS
IDEAS, HIS WORDS,
HIS SMILE AND MOST
OF ALL HIS PASSION
FOR AMERICA HAD
MORE INFLUENCE
ON THE WORLD THAN
MOST OF SO CALLED
"INTELLECTUAL"
PRESIDENTS OF
HIS TIME. REAGAN
HAD INFLUENCE
BECAUSE HE WAS
RIGHT AND
AMERICA KNEW
IT.

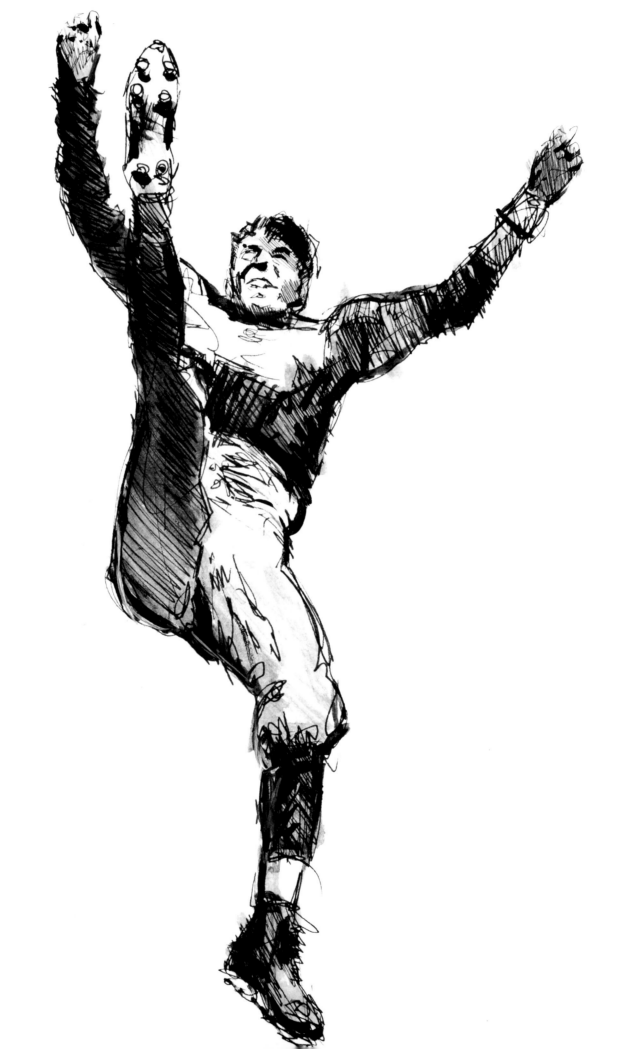

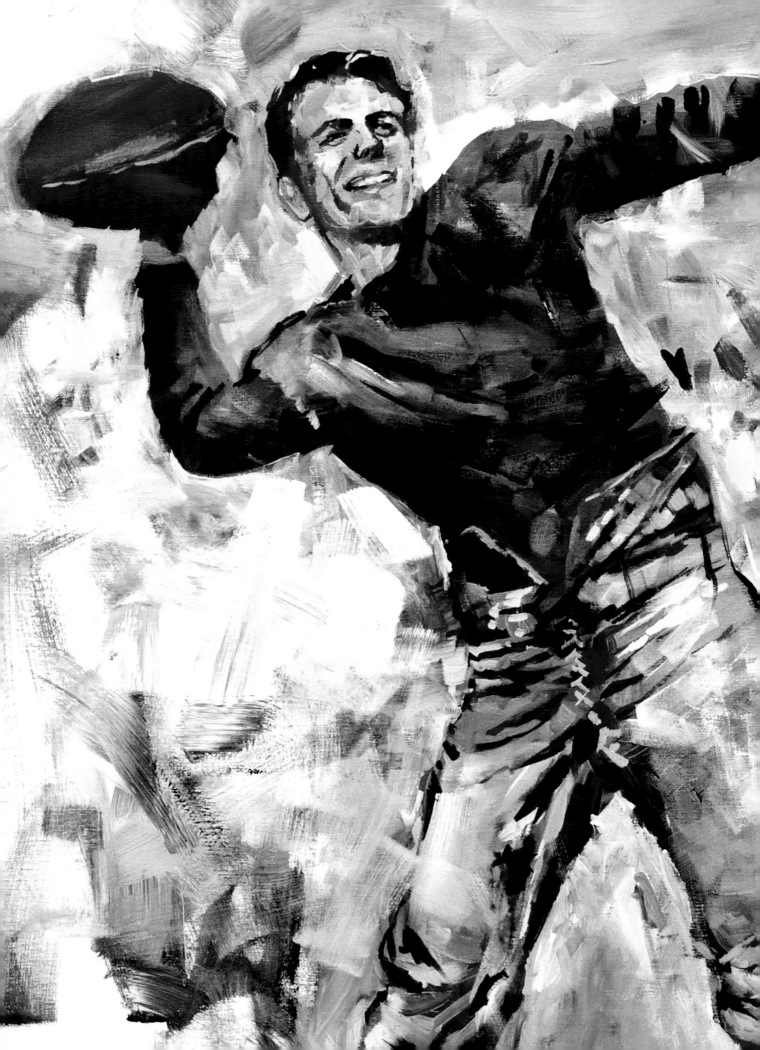

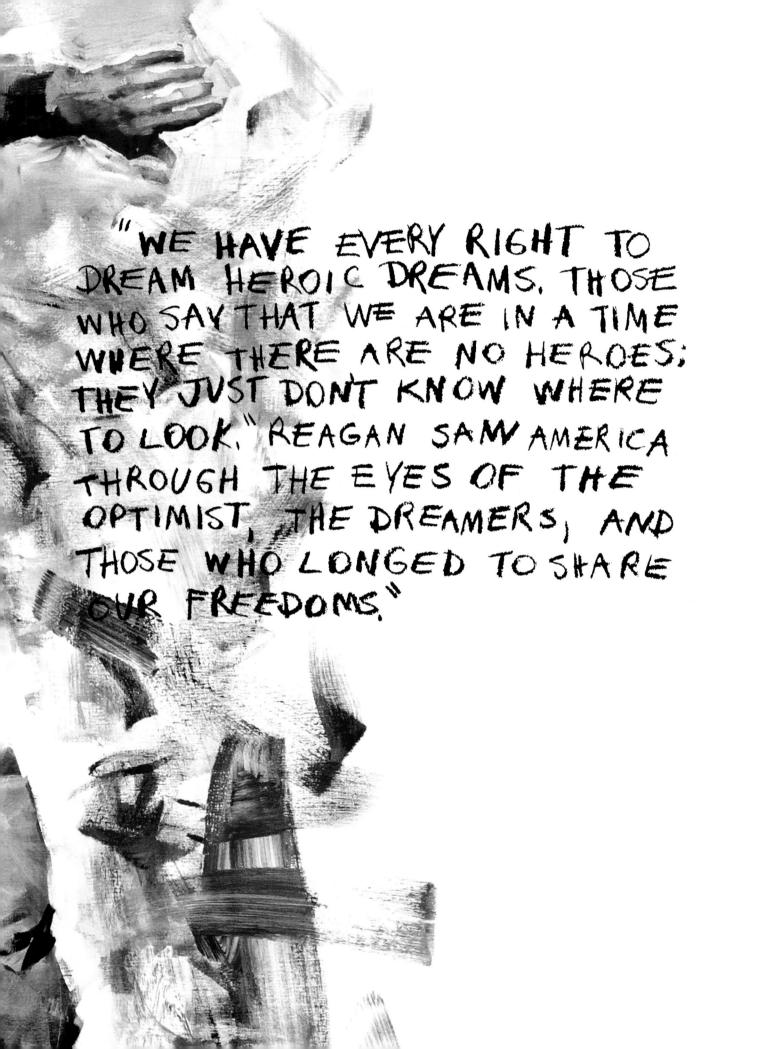

"WE HAVE EVERY RIGHT TO DREAM HEROIC DREAMS. THOSE WHO SAY THAT WE ARE IN A TIME WHERE THERE ARE NO HEROES; THEY JUST DONT KNOW WHERE TO LOOK." REAGAN SAW AMERICA THROUGH THE EYES OF THE OPTIMIST, THE DREAMERS, AND THOSE WHO LONGED TO SHARE OUR FREEDOMS."

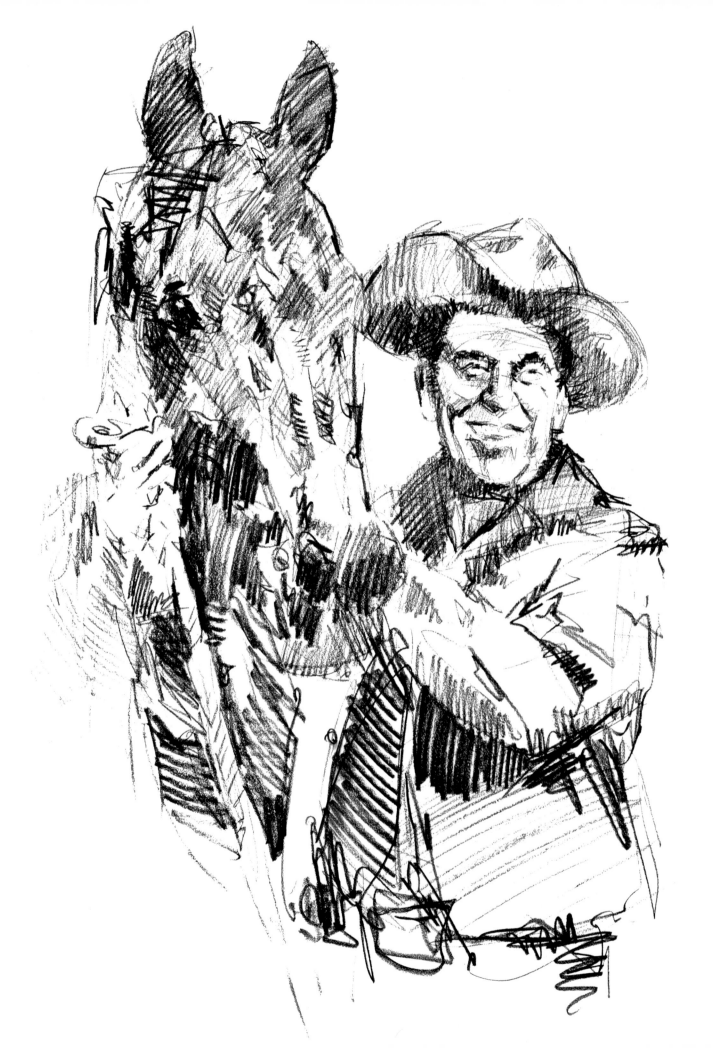

"I heard one presidential candidate say what this country needed was a president for the nineties. I was set to run again. I thought he said a president in his nineties."

EVEN THOUGH
REAGAN BECAME
THE LEADER OF
THE FREE WORLD,
HIS HEART NEVER
LEFT DIXON.
HIS TASTES WERE
SIMPLE AND HIS
IDEAS WERE
GROUNDED IN
PRINCPLE. HE
BELIEVED GOD
HAD A PLAN FOR
HIS LIFE AND
JUST WANTED
TO PLAY HIS
ROLE.

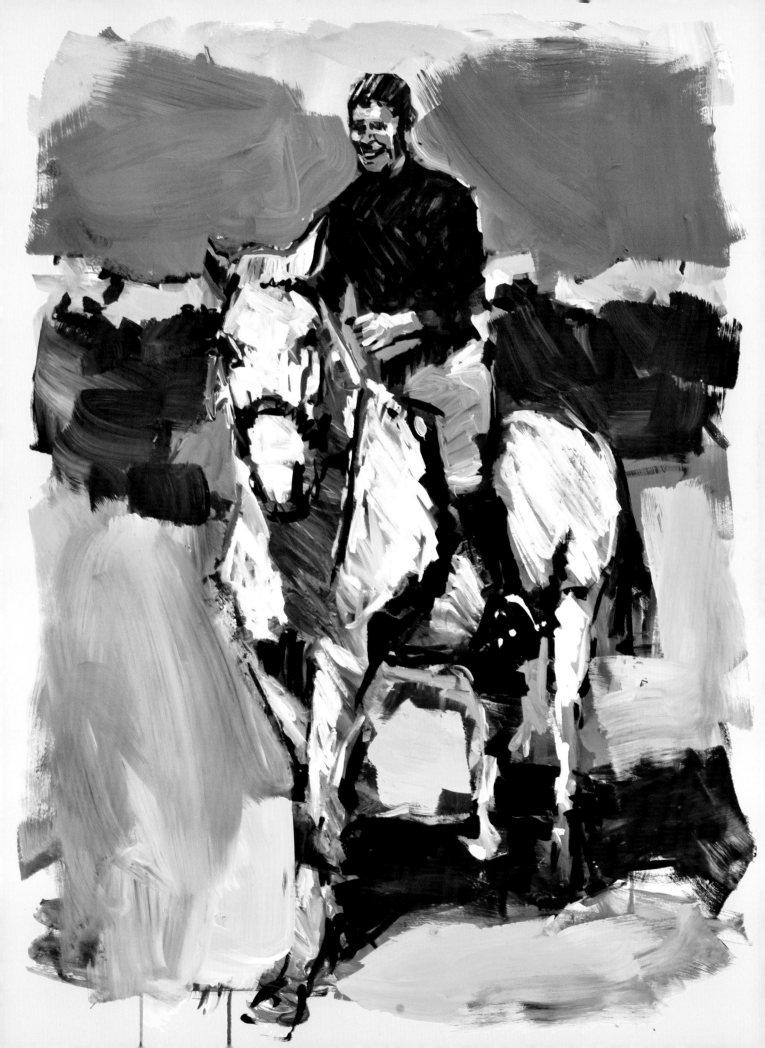

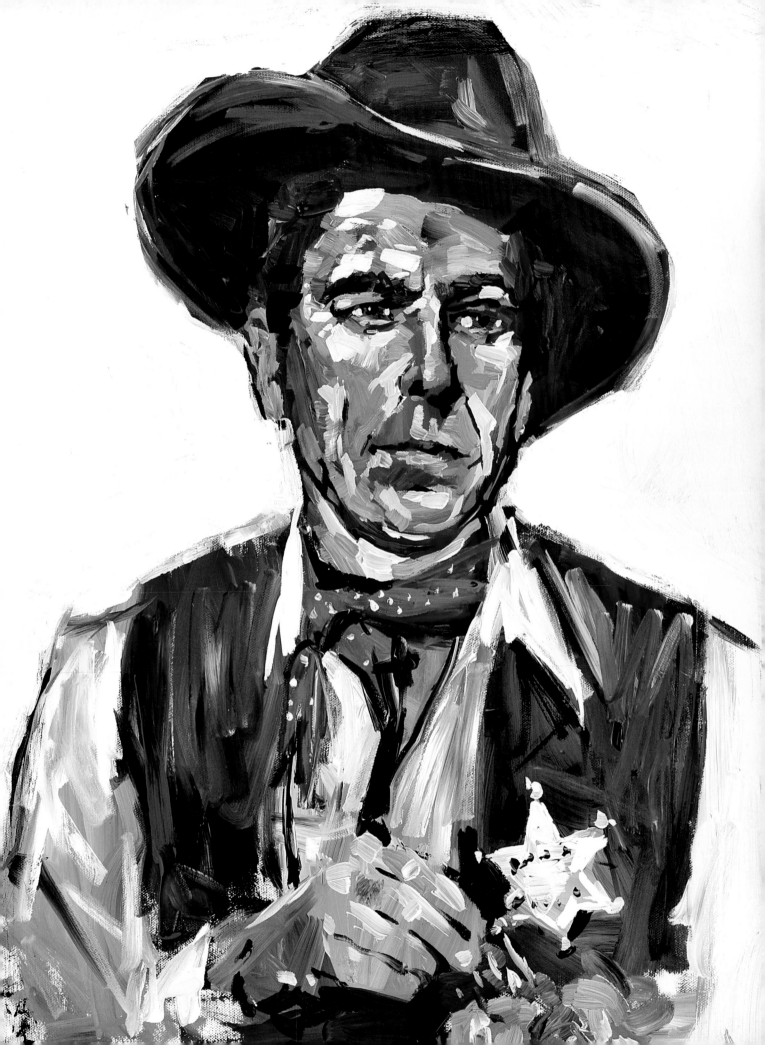

THE OLD WESTERNS OF FILM
AND TELEVISION RESONATED
WITH US ALL BECAUSE THEY
SYMBOLIZED OUR LOVE
OF GOOD WINNING OUT OVER
EVIL.

OUR WESTERN HEROES
FILL A NEED WE
HAVE TO CONNECT
WITH A TIME WHEN
AMERICAN VIRTUE
WAS A LITTLE MORE
CLEAR.

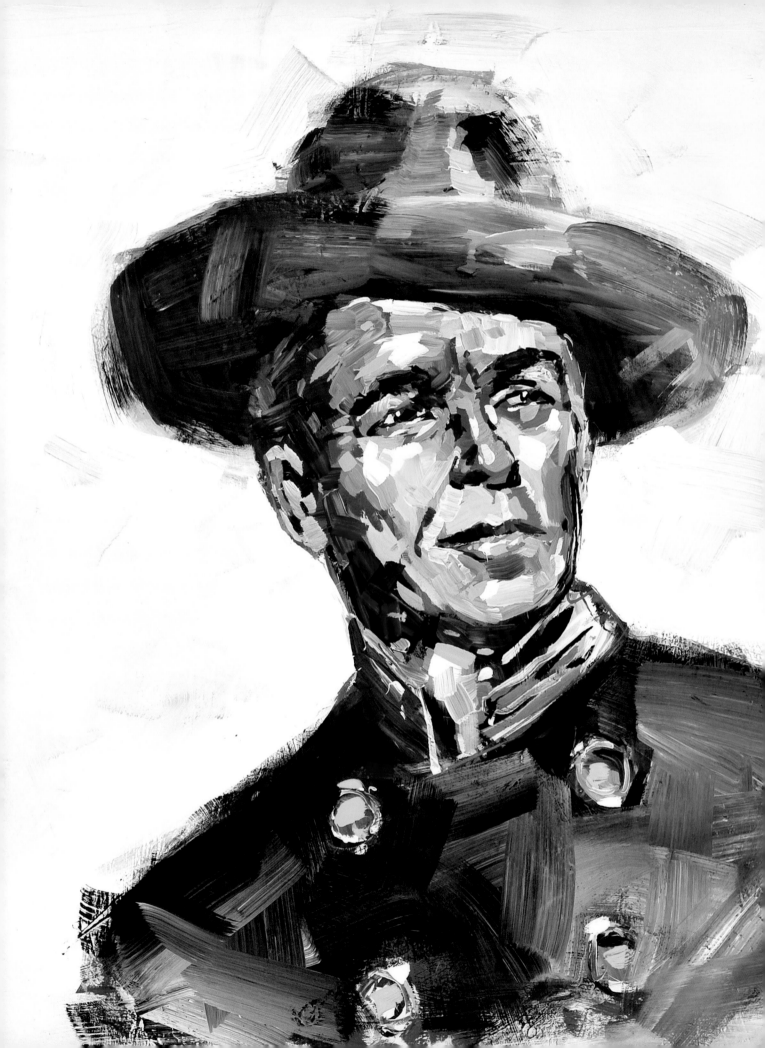

REAGAN RECOGNIZED
EVIL AND CALLED IT
WHAT IT WAS.

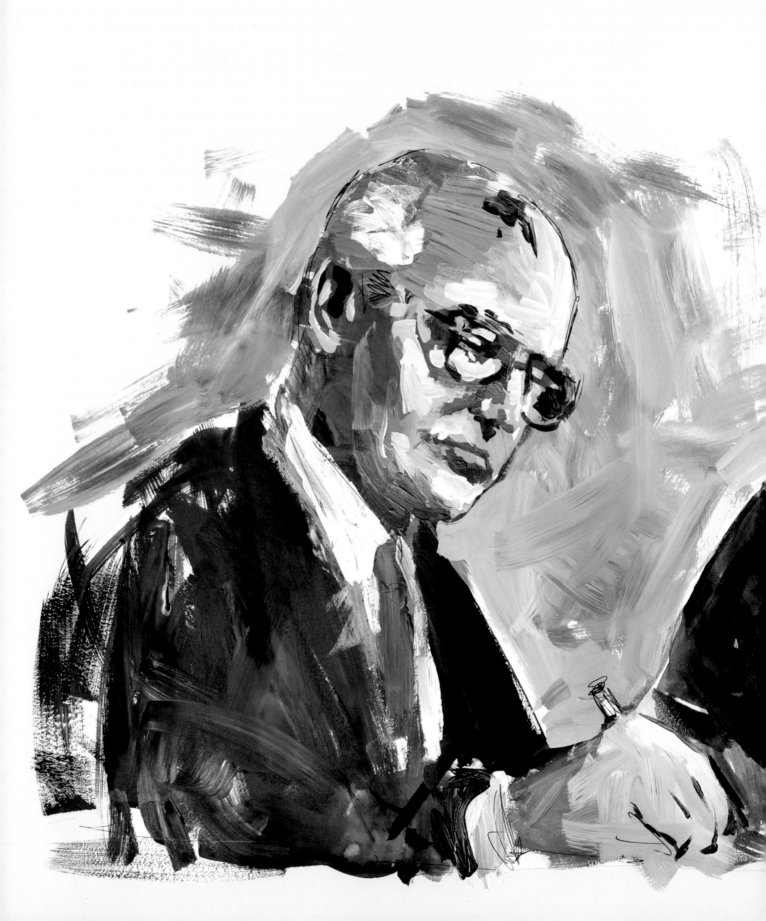

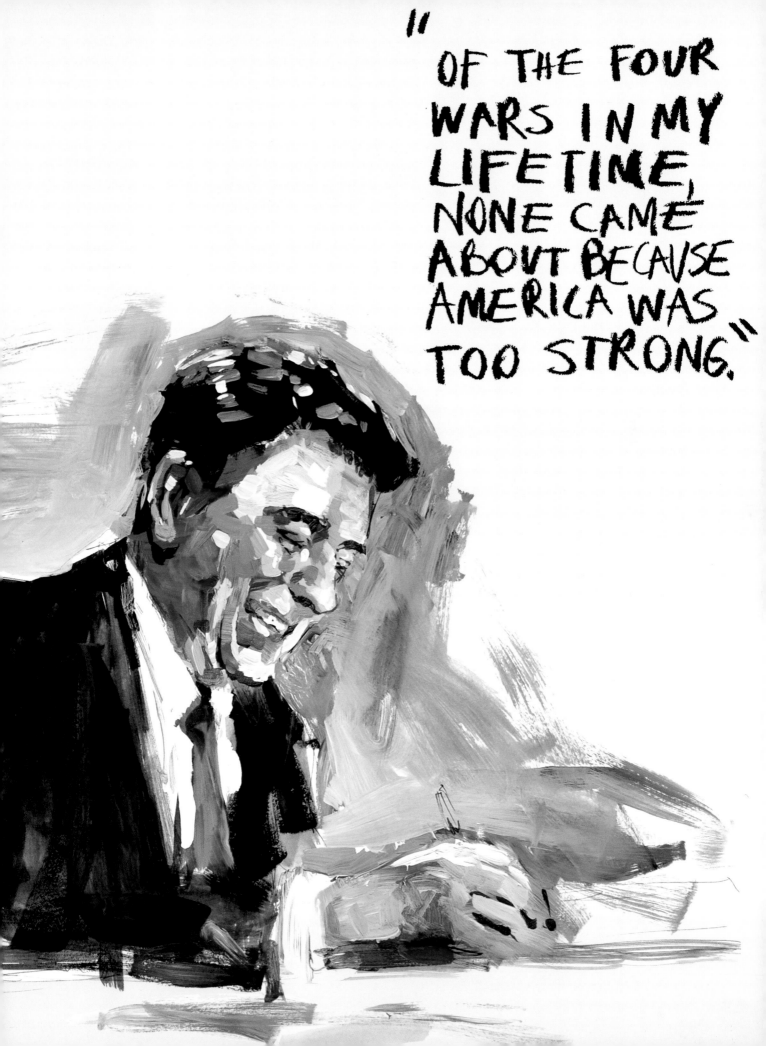

"OF THE FOUR WARS IN MY LIFETIME, NONE CAME ABOUT BECAUSE AMERICA WAS TOO STRONG."

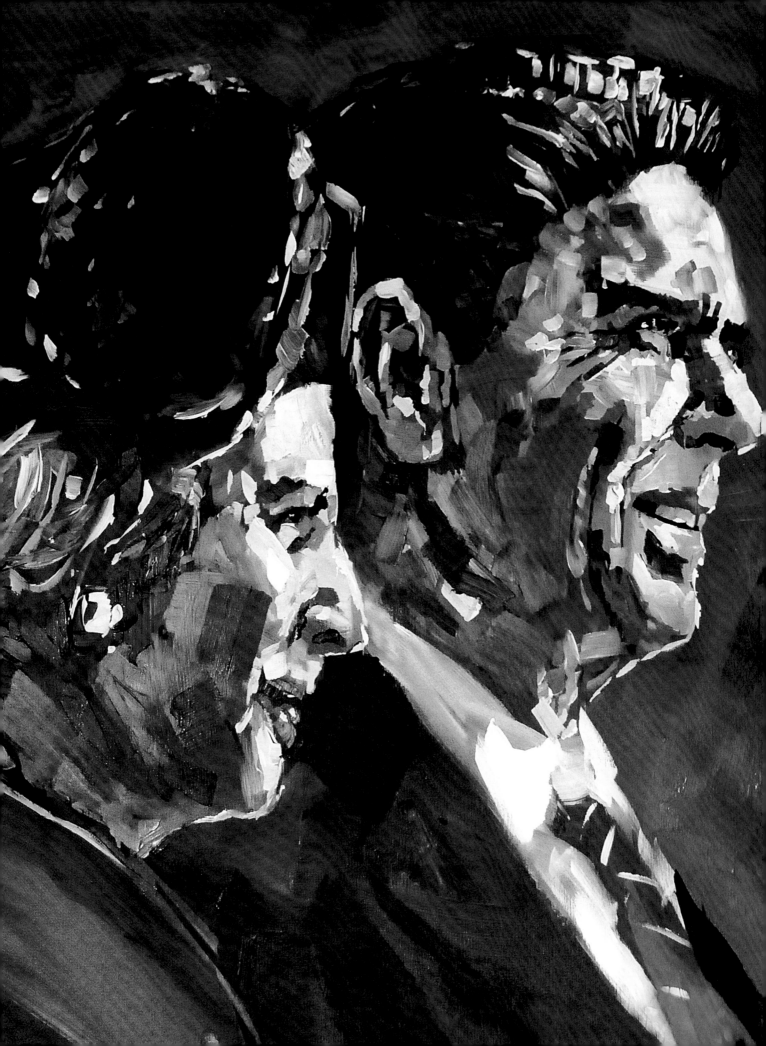

"NO GOVERNMENT EVER VOLUNTARILY REDUCES ITSELF IN SIZE. GOVERNMENT PROGRAMS, ONCE LAUNCHED, NEVER DISAPPEAR. ACTUALLY, A GOVERNMENT BUREAU IS THE NEAREST THING TO ETERNAL LIFE WE'LL EVER SEE ON THIS EARTH."

"THE BEST MINDS ARE NOT IN GOVERNMENT. IF ANY WERE, BUSINESS WOULD HIRE THEM AWAY."

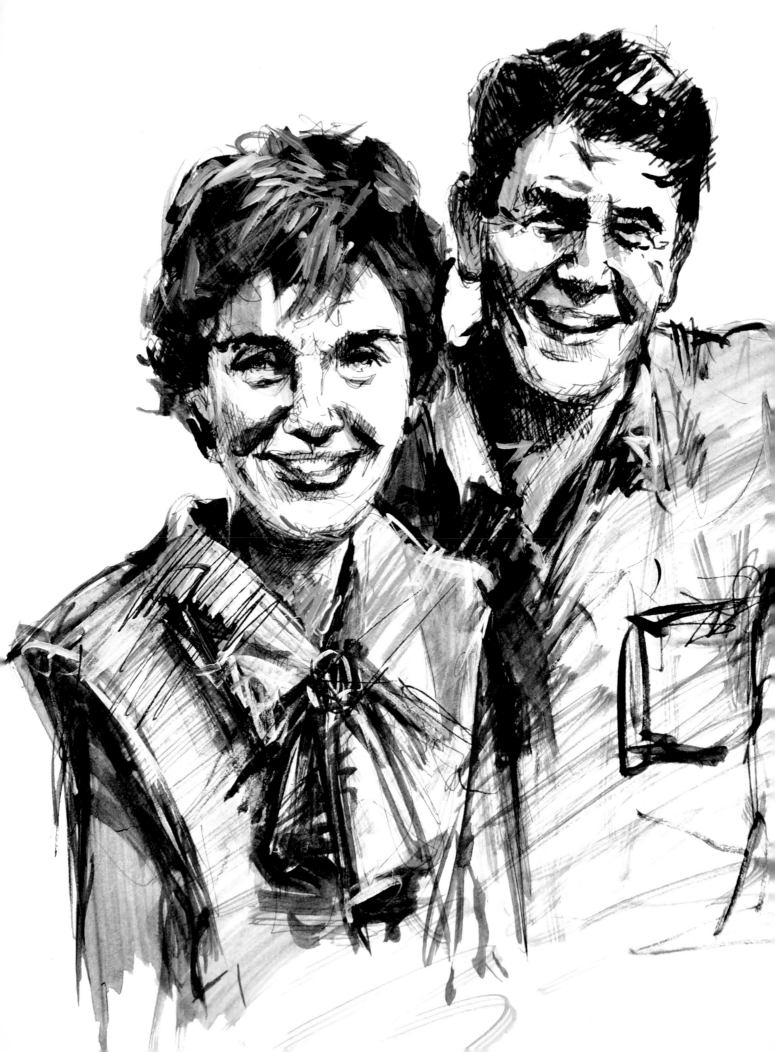

FREEDOM IS AN IDEA
THAT BURNS IN THE HEART
OF MOST EVERY MAN,
WOMAN AND CHILD ALIVE.

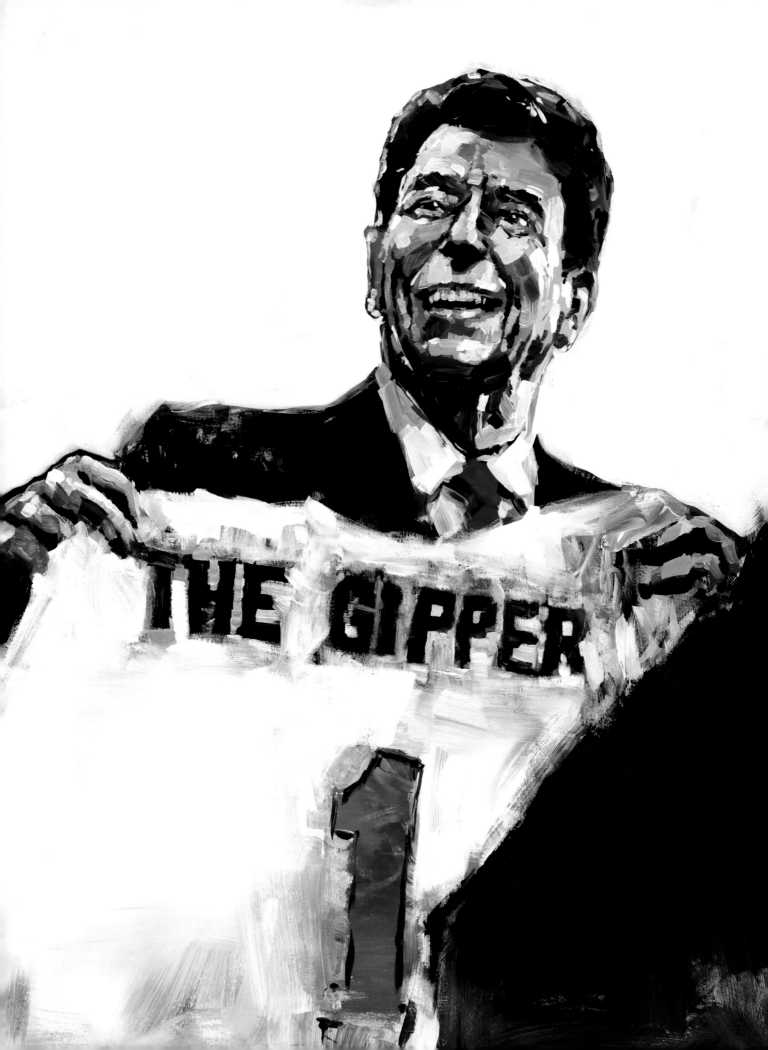

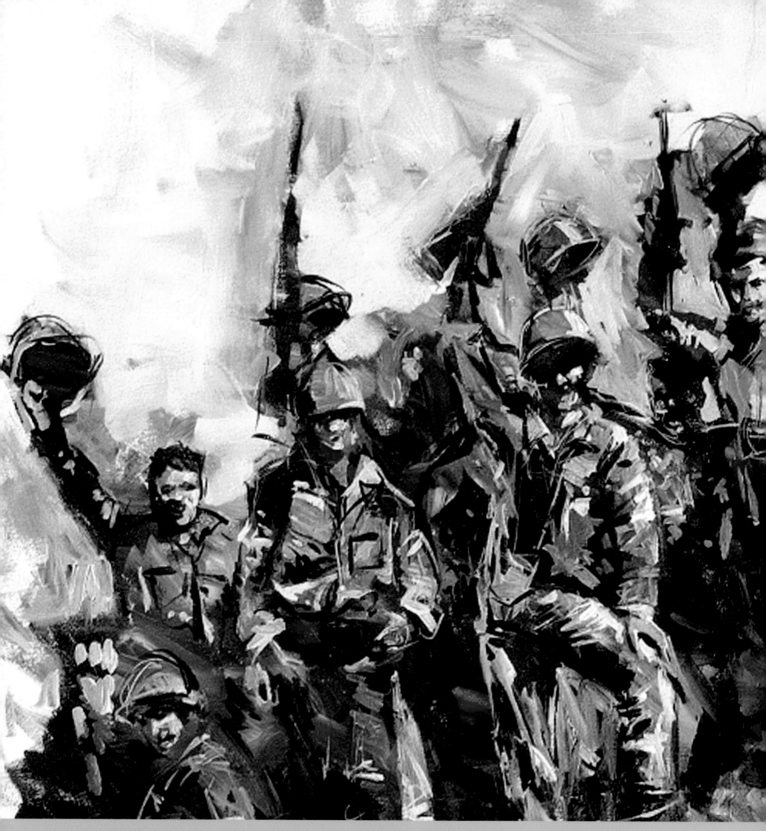

REAGAN UNDERSTOOD THAT
AMERICA WAS THE LAST STAND
ON EARTH FOR THE LIBERTY
OF MEN, HE KNEW THAT IF
WE LOST FREEDOM HERE

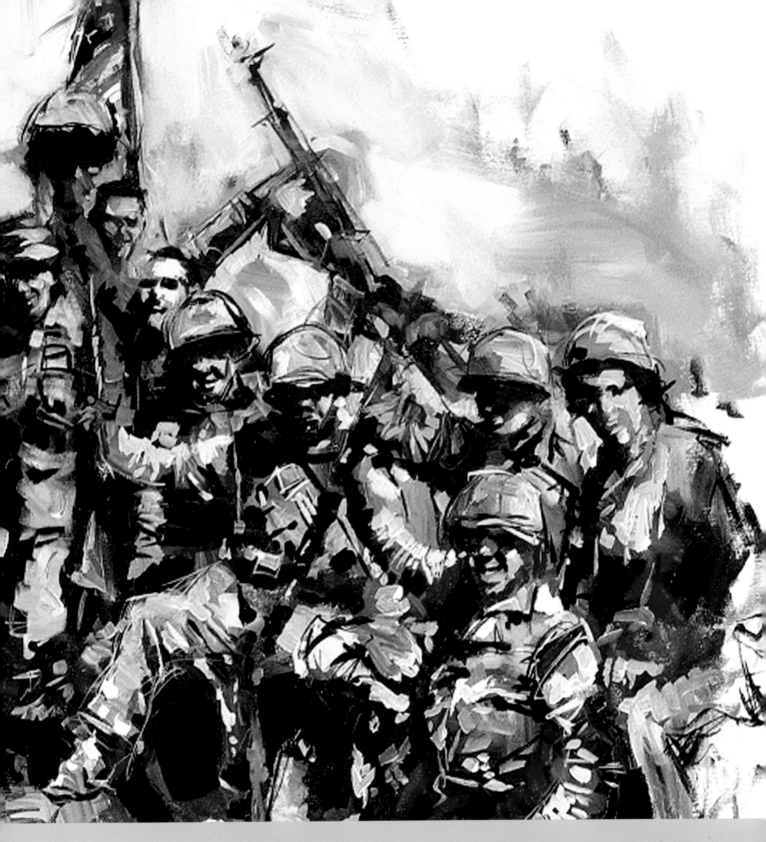

IT WOULD BE LOST EVERYWHERE.
NOW IS THE TIME TO TEACH
OUR CHILDREN WHY RONALD
REAGAN WAS A REFLECTION
OF THE AMERICAN IDEAL.

"I AM NOT GOING TO EXPLOIT FOR POLITICAL PURPOSES MY OPPONENT'S YOUTH AND INEXPERIENCE."

AMERICAN STRENGTH
PROTECTS THE
LIBERTIES OF HER
PEOPLE HERE
AT HOME, AND
MANY MORE
AROUND THE
WORLD.
"NO ARSENAL, OR
NO WEAPON
IN THE ARSENALS
OF THE WORLD,
IS SO FORMIDABLE
AS THE WILL AND
MORAL COURAGE
OF FREE MEN
AND WOMEN."

AS LONG AS WE
STAY FREE
AMERICA WILL

STAY STRONG.

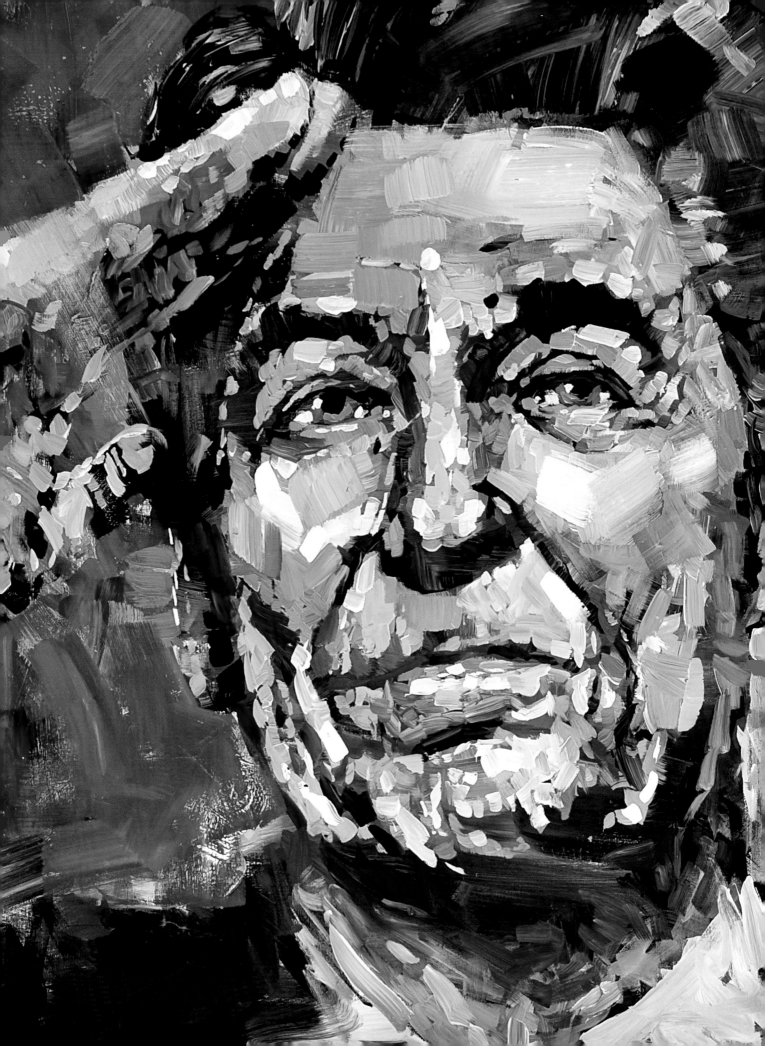

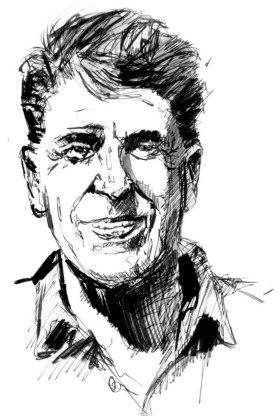

"POLITICS IS JUST LIKE SHOW BUSINESS. YOU HAVE A HELL OF AN OPENING, COAST FOR A WHILE, AND THEN HAVE A HELL OF A CLOSE."

"I HAVE LEFT ORDERS TO BE AWAKENED AT ANY TIME IN CASE OF NATIONAL EMERGENCY, EVEN IF I'M IN A CABINET MEETING."

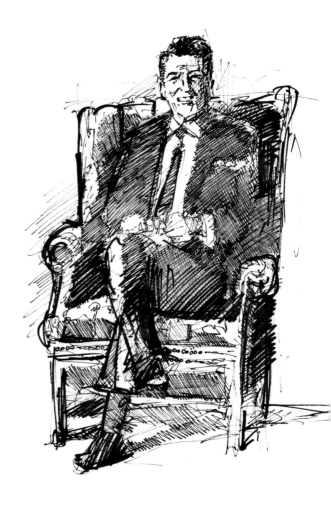

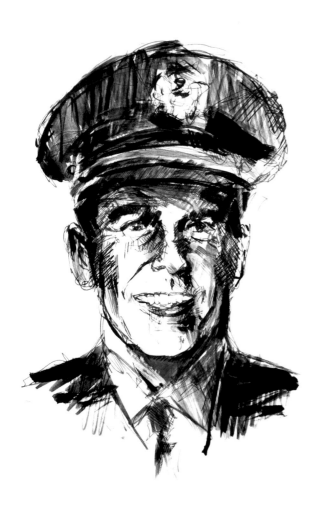

"TO SIT BACK HOPING SOMEDAY, SOME WAY, SOMEONE WILL MAKE THINGS RIGHT IS TO GO ON FEEDING THE CROCODILE, HOPING HE WILL EAT YOU LAST—BUT EAT YOU HE WILL."

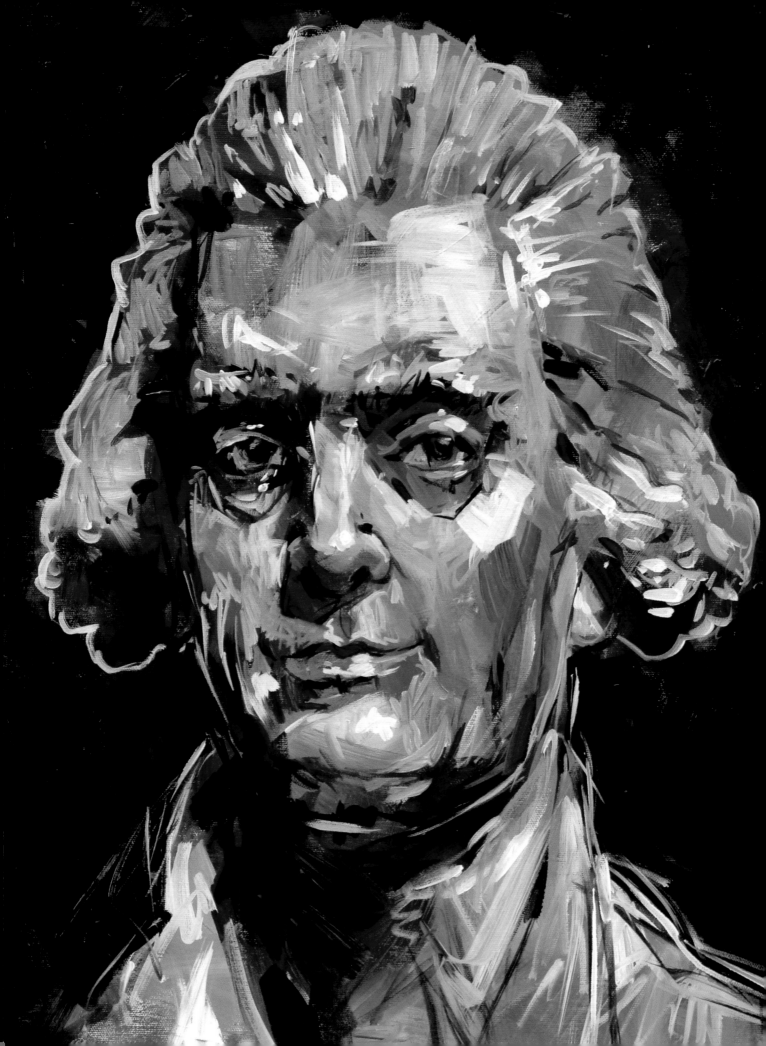

TO HIM THERE WAS NO LIMIT
ON THE POTENTIAL OF HUMAN
CAPACITY FOR INTELLIGENCE
AND IMAGINATION. HE DID NOT
THINK THAT AMERICANS WERE
BETTER BECAUSE OF SOME KIND
OF RACIAL OR ETHNIC CHARACTERISTIC,
BUT BECAUSE OF THE SPIRIT OF
THOSE WHO CAME TO AMERICA
IN THE BEGINNING HAD FOR
FREEDOM AND INGENUITY.
 THE AMERICAN SPIRIT UNLEASHED
MEN TO BE THE BEST THEY COULD
BE. FOR AMERICANS THERE WOULD
ALWAYS BE A BRIGHT DAWN
AHEAD.

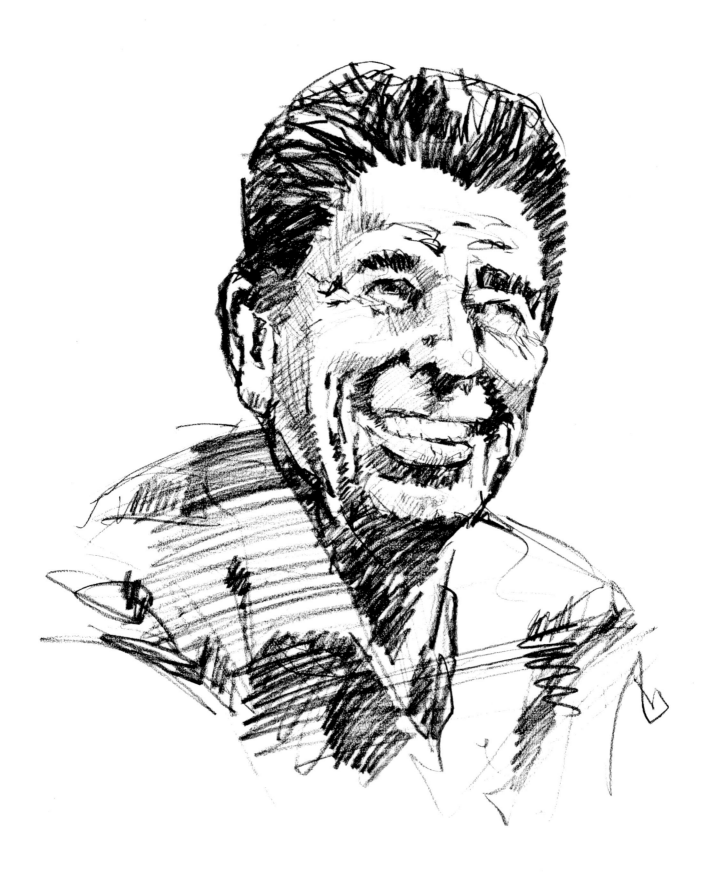

"HEROES MAY NOT BE BRAVER THAN ANYONE ELSE, THEY'RE JUST BRAVE FIVE MINUTES LONGER."

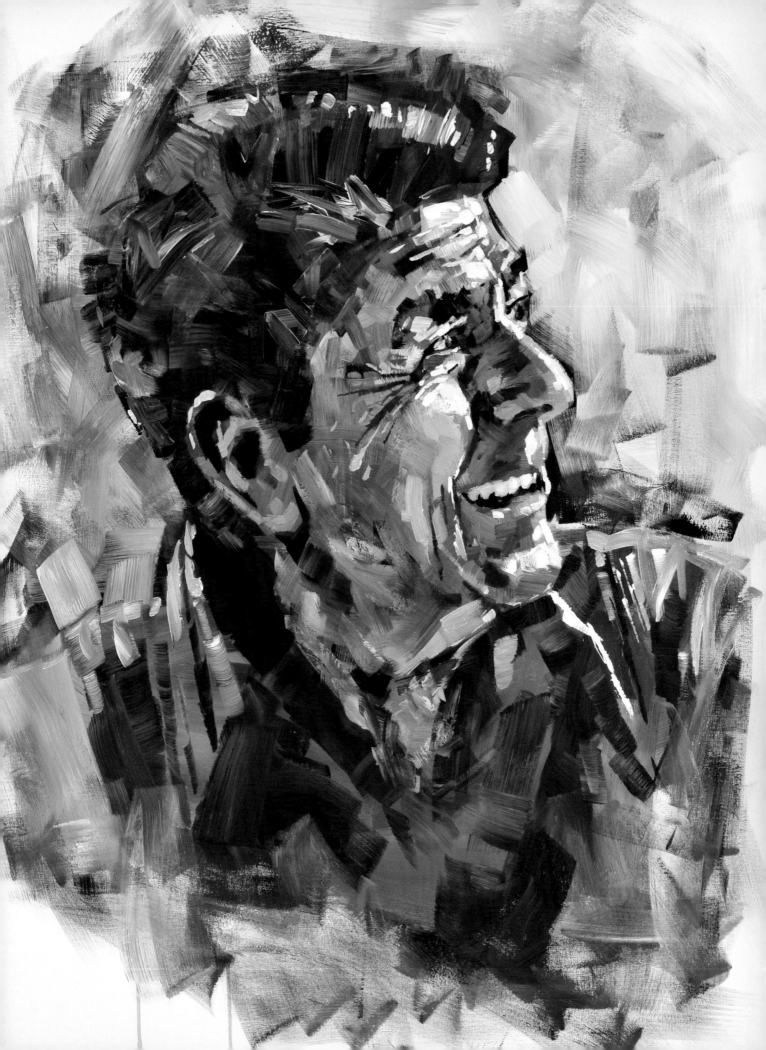

"DON'T BE AFRAID TO SEE WHAT YOU SEE."

"PEACE IS MORE THAN JUST THE ABSENCE OF WAR. TRUE PEACE IS FREEDOM. AND TRUE PEACE DICTATES THE RECOGNITION OF HUMAN RIGHTS."

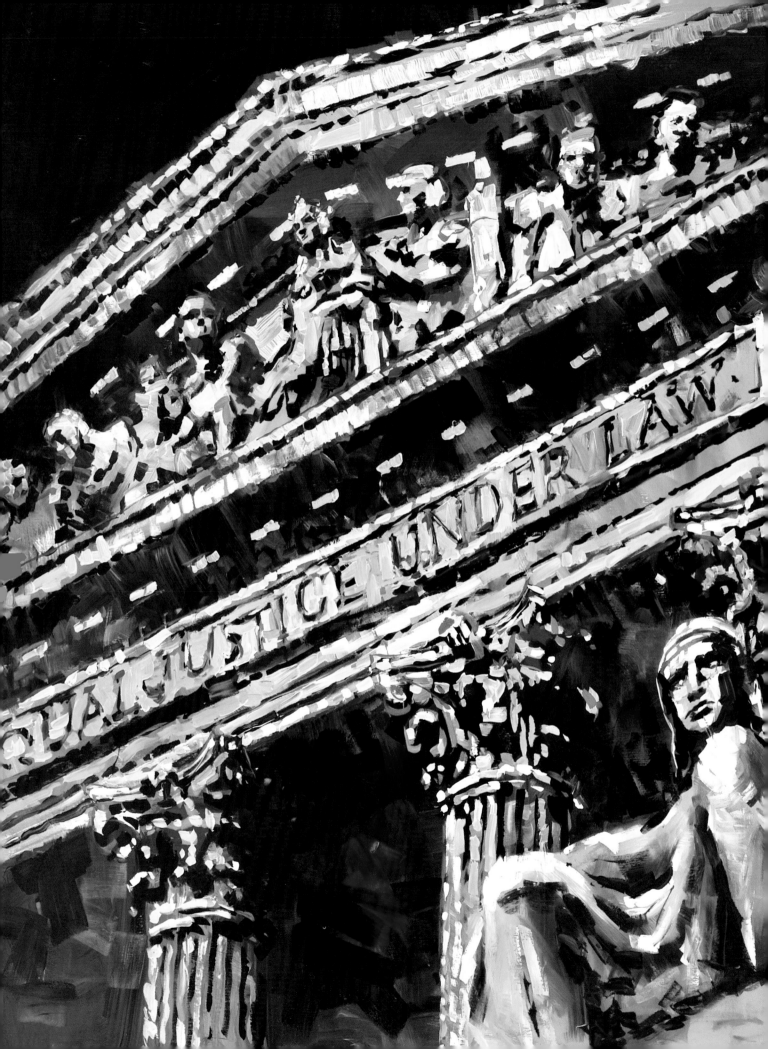

" HERE'S MY STRATEGY ON THE COLD WAR: WE WIN; THEY LOSE. "

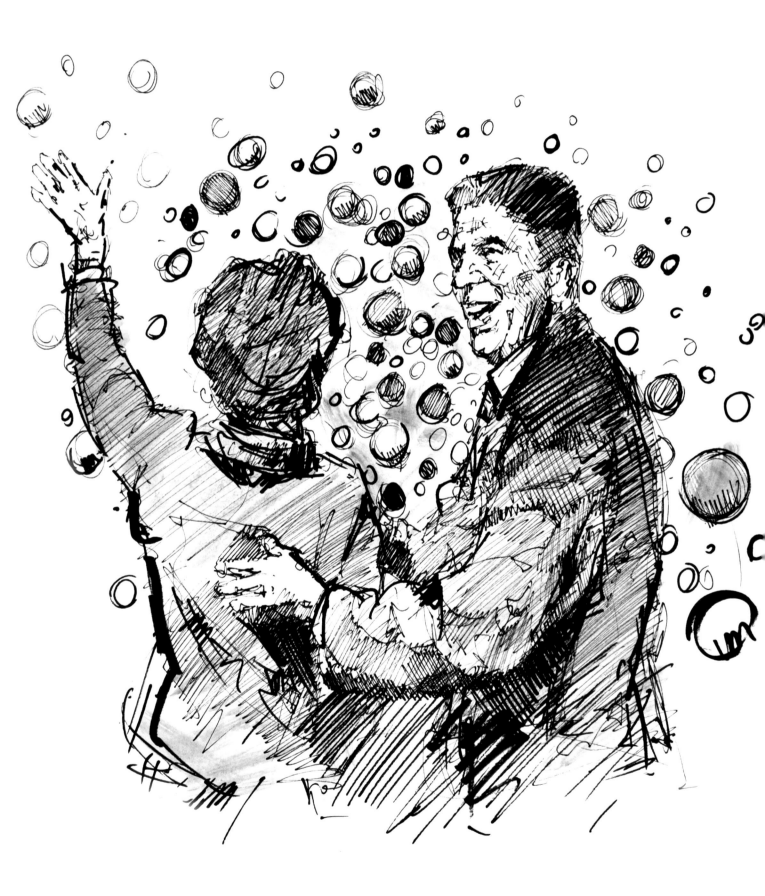

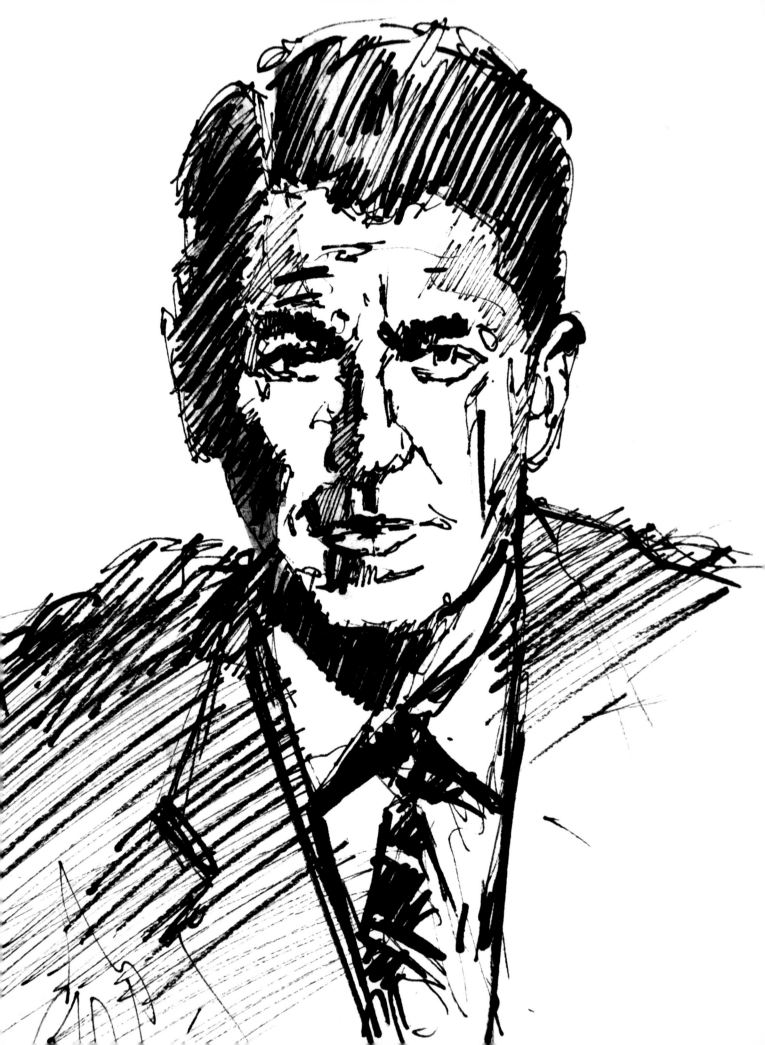

AMERICA HAS LIT THE
TORCH OF FREEDOM
FOR MEN AND WOMEN
ALL AROUND THE
WORLD.

"YOU ARE THE LIGHT OF THE WORLD. A CITY ON A HILL CANNOT BE HIDDEN." MATTHEW 5:14

IN HIS MIND AMERICA WAS A FORCE FOR PEACE. WE ARE RARELY THANKED FOR THE COUNTLESS MILLIONS WE HAVE KEPT FREE.

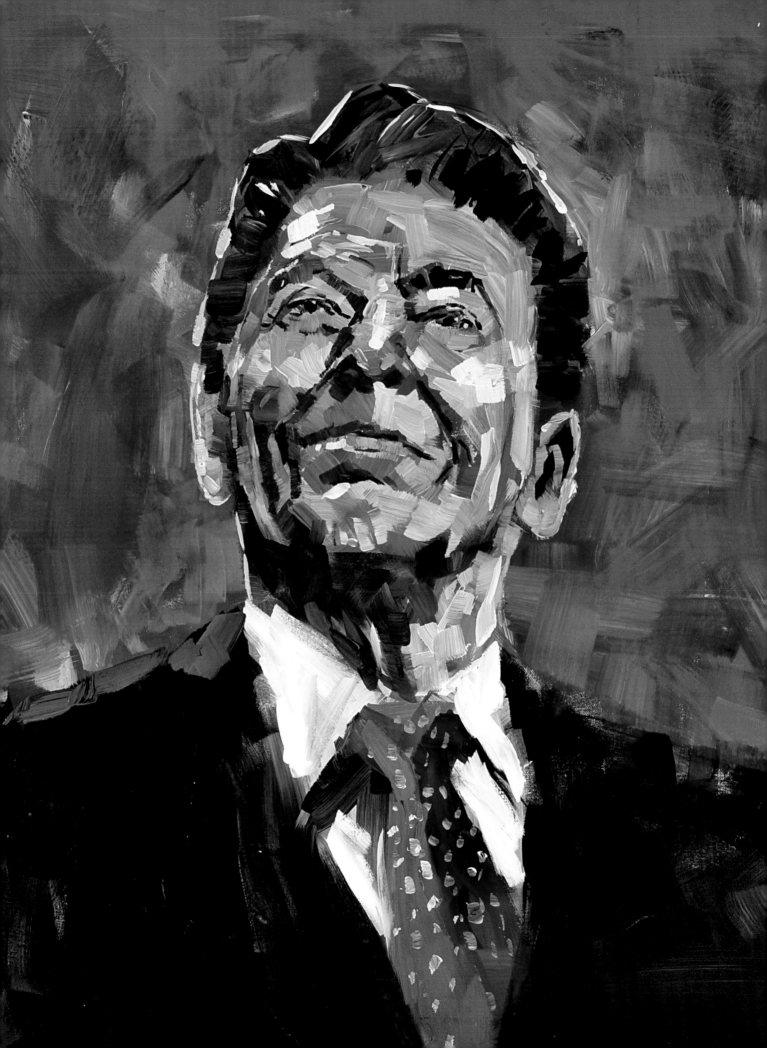

REAGAN LET US STAND
TALL AGAIN.

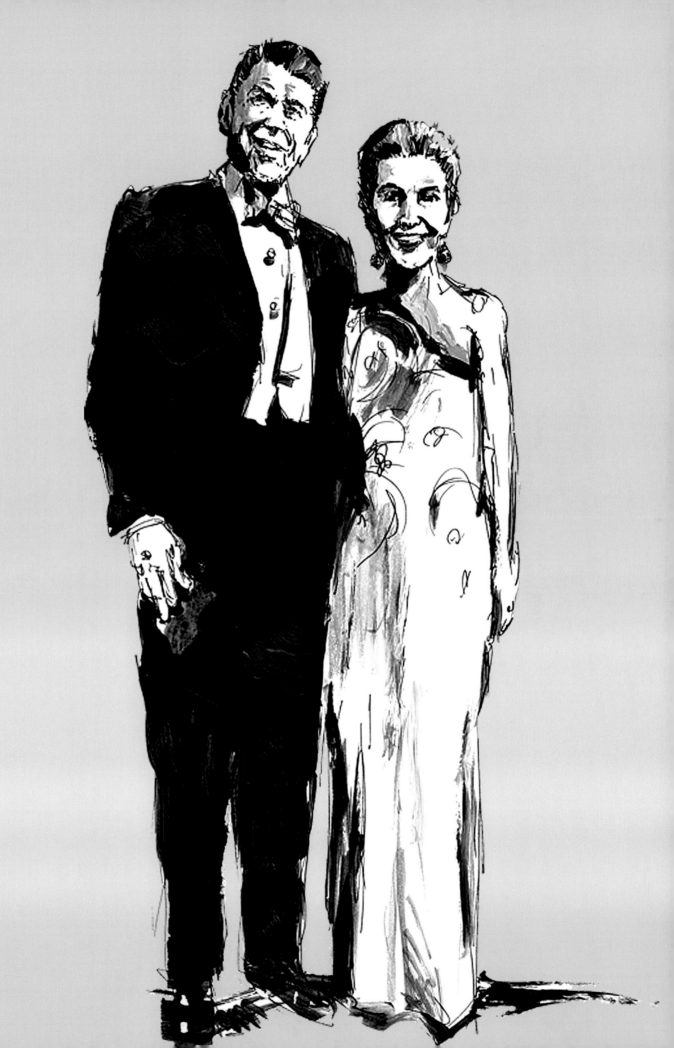

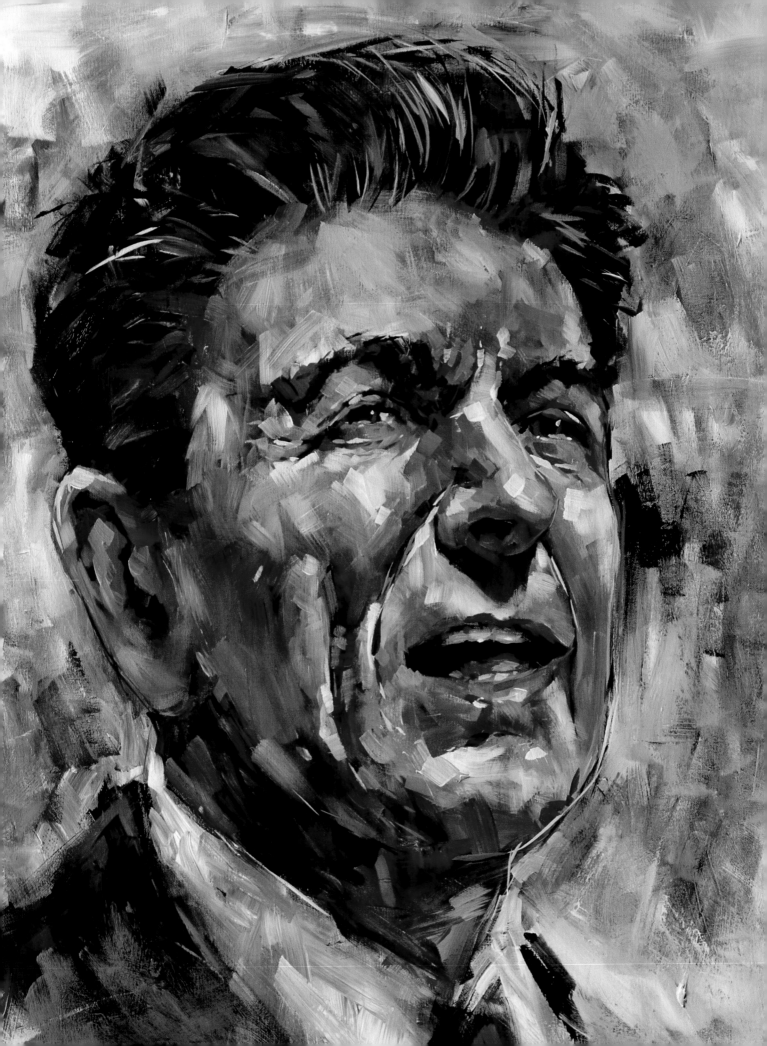

REAGAN BELIEVED THAT
GOD PLACED THIS COUNTRY
BETWEEN TWO GREAT
OCEANS TO BE FOUND BY
PEOPLE FROM EVERY
CORNER OF THE WORLD;
TO BE FOUND BY THOSE
WHO DREAMED OF BEING
FREE.

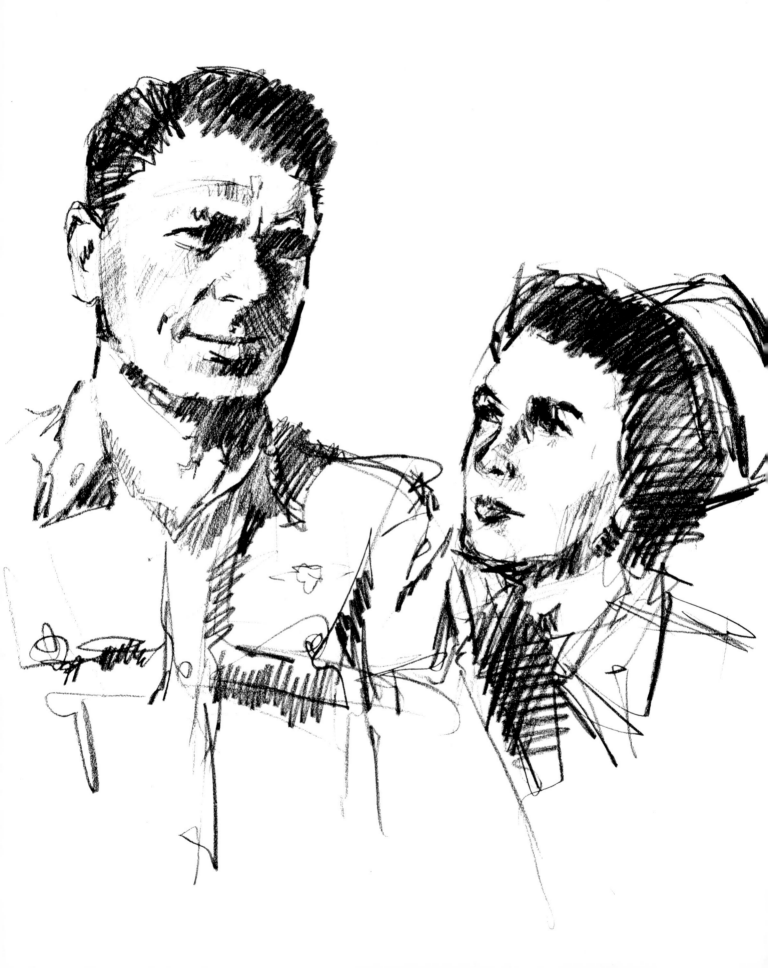

"THOSE PICTURES WITH NO FOUR-LETTER WORDS, NO NUDE SCENES, NO BLATANT SEX, NO VULGARITY, WERE BETTER THEATRE THAN TODAY'S REALISM."

"FOR THOSE OF YOU IN THE PRESS WHO PRIDE YOURSELF FOR YOUR ACCURACY, NO I WAS NOT THERE WHEN WASHINGTON TOOK HIS OATH OF OFFICE."

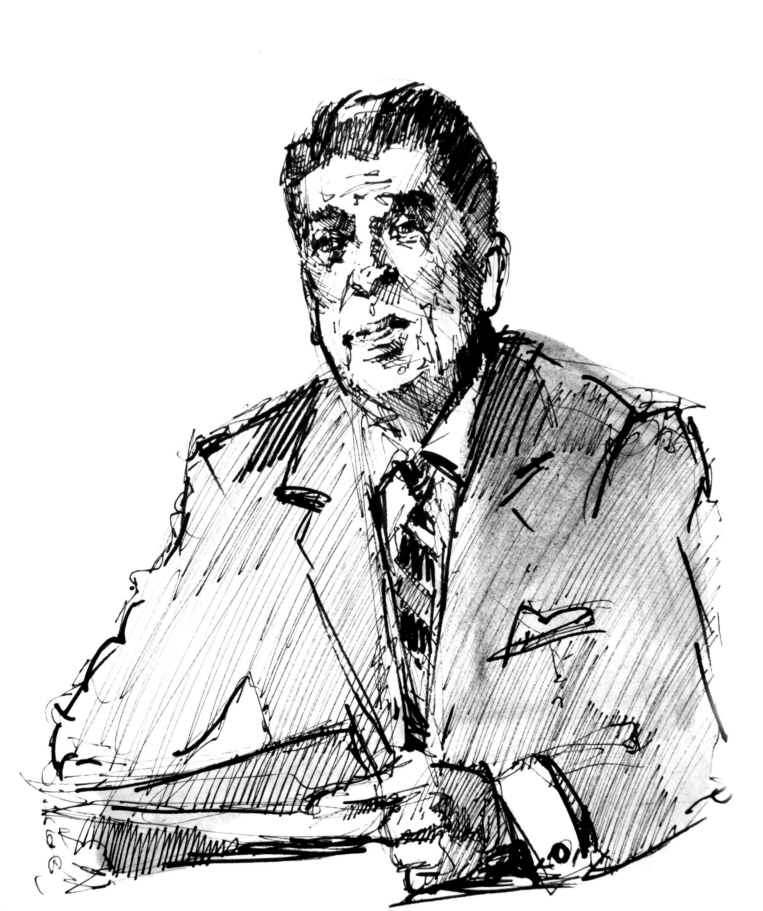

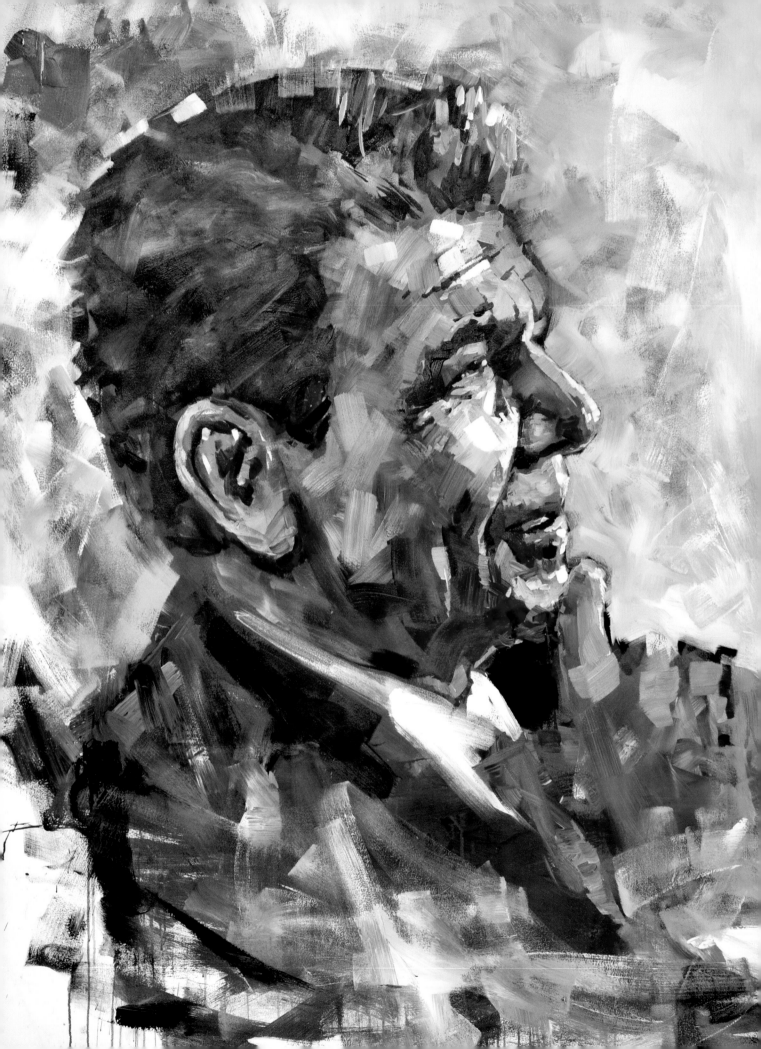

REAGAN, JUST AS WASHINGTON AND LINCOLN BEFORE HIM, DID NOT BELIEVE IN APPEASING EVIL. HE FOUGHT TYRANNY AND OPPRESSION AROUND THE WORLD AND WON.

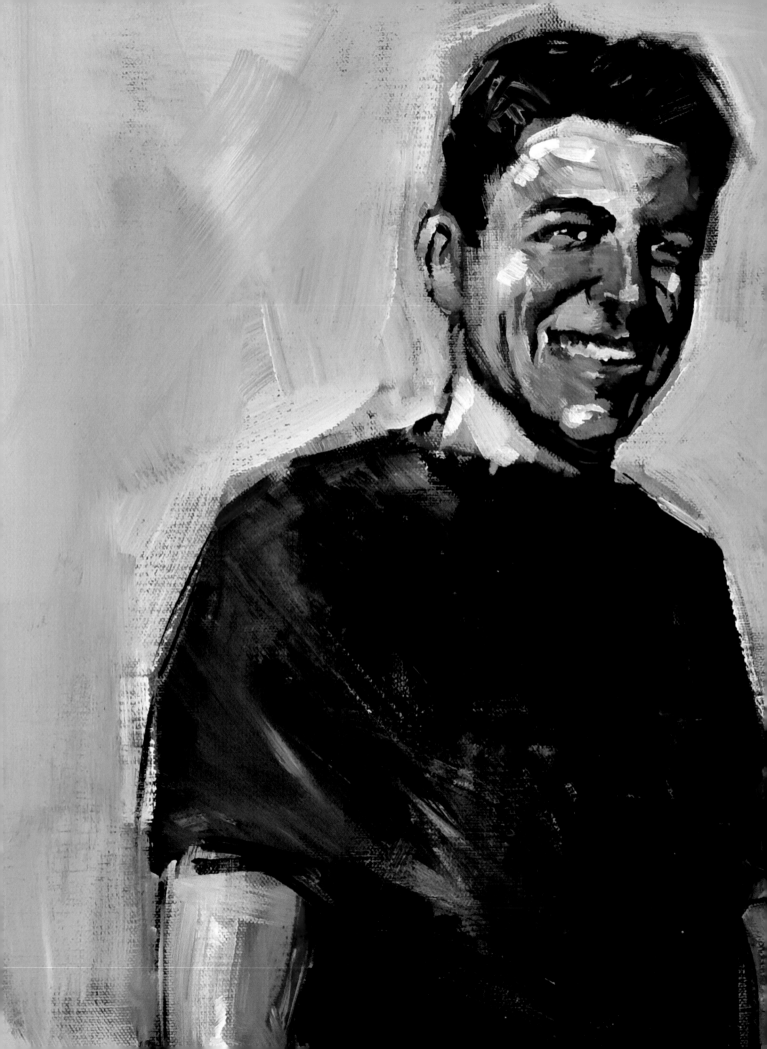

REAGAN BELIEVED THAT
FREEDOM LED TO PROSPERITY.
AMERICANS WERE FREE TO
PURSUE THEIR DREAMS AND
TO KEEP THE FRUITS OF
THEIR LABOR.

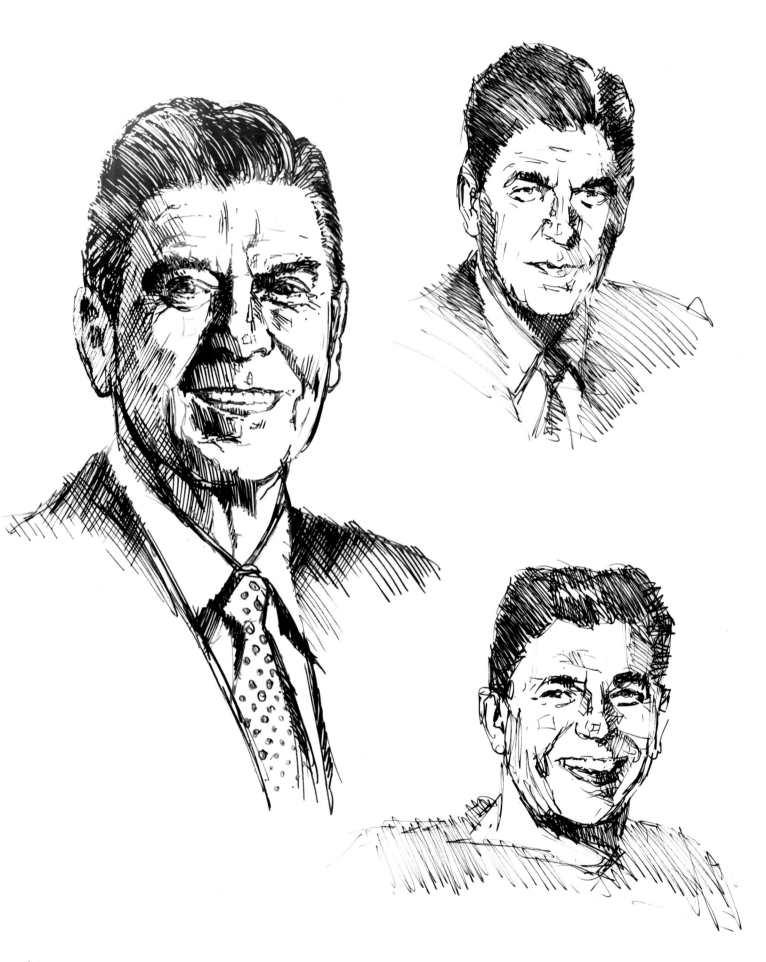

"WHILE I TAKE INSPIRATION FROM THE PAST

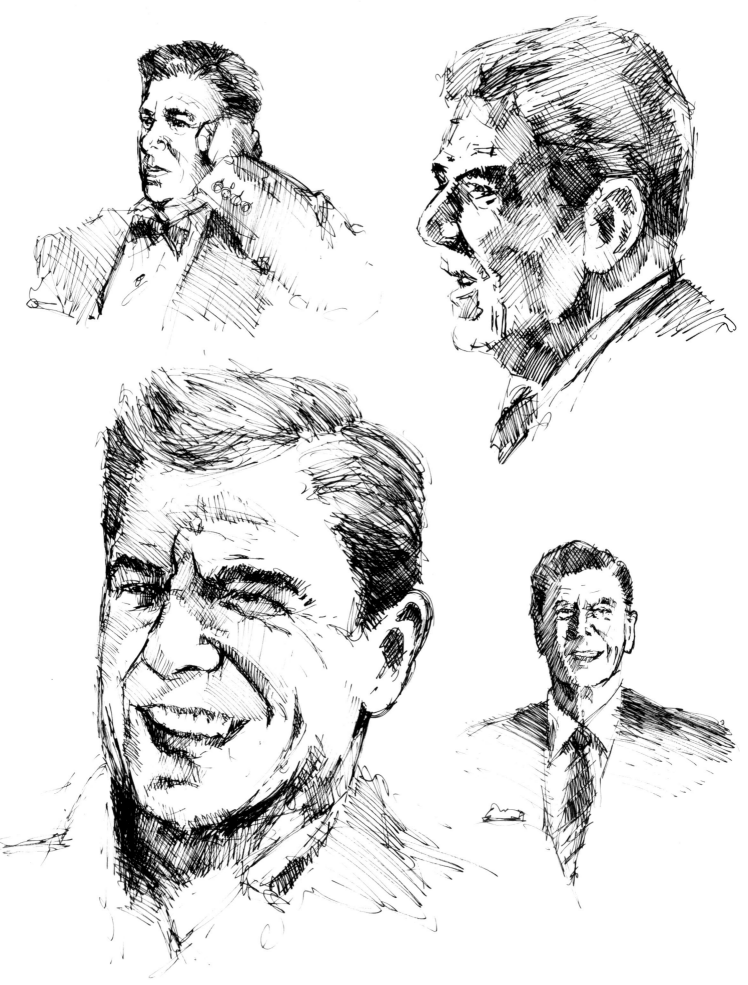

LIKE MOST AMERICANS, I LIVE FOR THE FUTURE."